CELEBRITY COCKTAILS

© 2014 Assouline Publishing
601 West 26th Street, 18th floor
New York, NY 10001, USA
Tel.: 212 989-6810 Fax: 212 647-0005
assouline.com
ISBN : 9781614282587
Printed in China.
Design by Camille Dubois. The photographs of the cocktails
featured in this book were shot at The Top of the Standard, New York.
All photographs, unless otherwise noted. © Harald Gottschalk.

BRIAN VAN FLANDERN

CELEBRITY COCKTAILS

PHOTOGRAPHS BY HARALD GOTTSCHALK

ASSOULINE

Foreword

It's safe to say that we are currently experiencing the second coming of the Golden Age of Cocktails. The first, glamorous era of the cocktail ended abruptly when Prohibition began in 1920. The time before Prohibition, when many of the great classics were either created or perfected, must have been an amazing time to have been a professional bartender. The highbrow, high-heeled, and well-dressed crowd mingled with celebrities and the cocktails flowed—all in tune with the beautiful melody of hand-cut ice clinking in a sterling silver cocktail shaker.

Historically, celebrities have played a crucial role in both the creation of new cocktails and bringing attention to and popularizing others. Brian Van Flandern embraces the profession, educates many, and has helped elevate the craft to where it is today. He is a leading force in the cocktail revival, and has helped change the way we see bartending today. His creative mind in cocktails, skill as an educator, and passion for the profession have inspired a new generation of bartenders to view mixology not as transitional job, but as rewarding career, where hospitality reigns supreme. Brian's approach in this book is simple: great cocktails do not have to be overly complicated. Just make sure you utilize great spirits, fresh seasonal produce, and proper balance and complexity, then bring it together skillfully in amazing glassware. Brian celebrates the cocktail in all its unpretentious glory.

Brian and I share a common belief: great ingredients in the hands of a skilled craftsperson can produce great cocktails. I had the great privilege of opening the Bellagio under Steve Wynn in 1998 with the aforementioned philosophy, while serving some of the most discerning guests in the world. I remember making vodka martinis for George Clooney and Jack Daniel's highballs for Julia Roberts, and turning Andy Garcia on to one of my originals, the Sunsplash, during the filming of *Ocean's Eleven*. Based on their feedback, I gather they all appreciated a well-made cocktail. Brian's journey into the world of celebrity mixology is firmly established, with stints at Thomas Keller's Per Se and New York's swank Bemelmans Bar inside the Carlyle Hotel. It was in joints like these that Brian mixed cocktails and exchanged stories with some of today's top celebrities, making him the perfect bartender to bring us *Celebrity Cocktails*. So slip into your smoking jacket or cocktail dress, put on a little Frank Sinatra, and invite some friends over. Make sure to shake your cocktails to a waltz, chill the glasses, open this book, and let your journey begin.

Tony Abou-Ganim
The Modern Mixologist

Introduction

There has been a connection between the film industry and the cocktail since the early days of Hollywood. As America emerged from the devastating effects of Prohibition (1920–1933), the Great Depression was in full swing. With millions of people out of work, they turned to the movies, drink, or both to find joy in their otherwise difficult lives. During Hollywood's Golden Era, stars and starlets were often depicted living the good life, dancing, smoking, and drinking, and these activities became glamorous, even romantic portraits of a rich and decadent lifestyle.

Over the last century, many classic cocktails have been referenced by name in the movies; indeed, many cocktails *became* classics because famous stars were seen drinking them on and off the screen. From Charlie Chaplin to Sarah Jessica Parker, celebrities have had a profound influence on the cocktail culture that is now a global phenomenon.

Most of the drinks in this book are simple classics or variations on a classic. Not everyone in the book was known for a particular cocktail, so I occasionally took the liberty of selecting a recipe that seemed appropriate based on characters they played throughout their careers. Each cocktail is shot in crystal glassware that you are not likely to find in any but the most opulent bars. Lalique, Baccarat, Versace, Fendi (Luxury Living), Waterford, and Rosenthal Crystal have all generously contributed from their respective

collections to allow me to showcase these classics in the manner in which they should be consumed. Accomplished photographer Harald Gottschalk is truly a master of light and shadow and successfully captures an organic composition in every photo.

The celebrities listed in this book represent some of the brightest and most interesting stars in the history of cinema. Many of them popularized cocktails and spirits that they didn't care for in their personal lives, while others drank nothing at all off the screen. Yet, most of the cocktails contained here are known to the masses and enjoy enduring reputations because of their affiliation with someone famous. Each recipe includes an entertaining anecdote about the stars as they relate to cocktails, spirits, or drinking in general. It is important to note, *especially with the living actors in this book,* that the cocktails beside their name do not necessarily represent their personal tastes or an endorsement, just a loose connection to the body of their work as iconic Hollywood royalty.

As a professional barman for over twenty-five years, I have had more than my fair share of celebrities saddle up to the bar. I have taken the liberty of sharing some of my memories of some of the more cordial encounters at Per Se restaurant and other establishments where I've worked. As a gentleman, the more sordid stories of the famous I'll keep to myself.

At the end of the day, the stars we idolize are just people—charming and often flawed. And just like you and me, their tastes vary from the ridiculously pedestrian to the elegant and refined.

As a beverage consultant, I am occasionally asked to create cocktails for celebrity events and parties, both public and private. In my experience, the vast majority of celebrities are down-to-earth people, often with strong opinions and passions about particular spirits and/or cocktails.

I once had the great pleasure of spending the better part of an evening with Kurt Russell, who was dressed as an airline captain at his stepdaughter's (Kate Hudson's) Halloween party. Mr. Russell is a fan of quality spirits, and as we spoke about the finer details of tequila production, he indicated that he enjoyed learning about how great spirits are made. Every personality in attendance made a point of dropping by the bar to introduce themselves to Mr. Russell, who immediately in turn introduced them to me. Mr. Russell's grace and charm are only exceeded by that of his longtime companion, Ms. Goldie Hawn who, at a later event, took the time to handwrite a thank-you note.

The cocktails in this book were shot at The Top of the Standard Hotel in New York City's meatpacking district. In what was formerly known as the Boom Boom Room, The Top of the Standard is a modern space with a timeless

feel. The room has a very retro look, with soft beige and gold-colored tones; one envisions that the space would appeal to the rich and famous in any decade over the last century.

The Top of the Standard has become a treasure hidden in plain sight, with stunning views of the Manhattan skyline. For years, the central focus was toward the north, with an incredible view of the Empire State Building. At the time this book was completed, the new Freedom Tower was in its final stages of construction and now lends a breathtaking view to the south. The Top of the Standard is an unheralded gem that New York's elite keep to themselves. It doesn't draw the same press or publicity as other iconic hotel bars throughout the city. Luminaries and locals who frequent the bar prefer it that way.

Please enjoy 100 years of Hollywood celebrities and the cocktails that they helped to make classics. I've also thrown in a couple cocktails of my own making, inspired by or dedicated to movie stars. Until our next cocktail together. . .

Bottoms up,

Brian Van Flandern
Founder of Creative Cocktail Consultants
& Master Mixologist

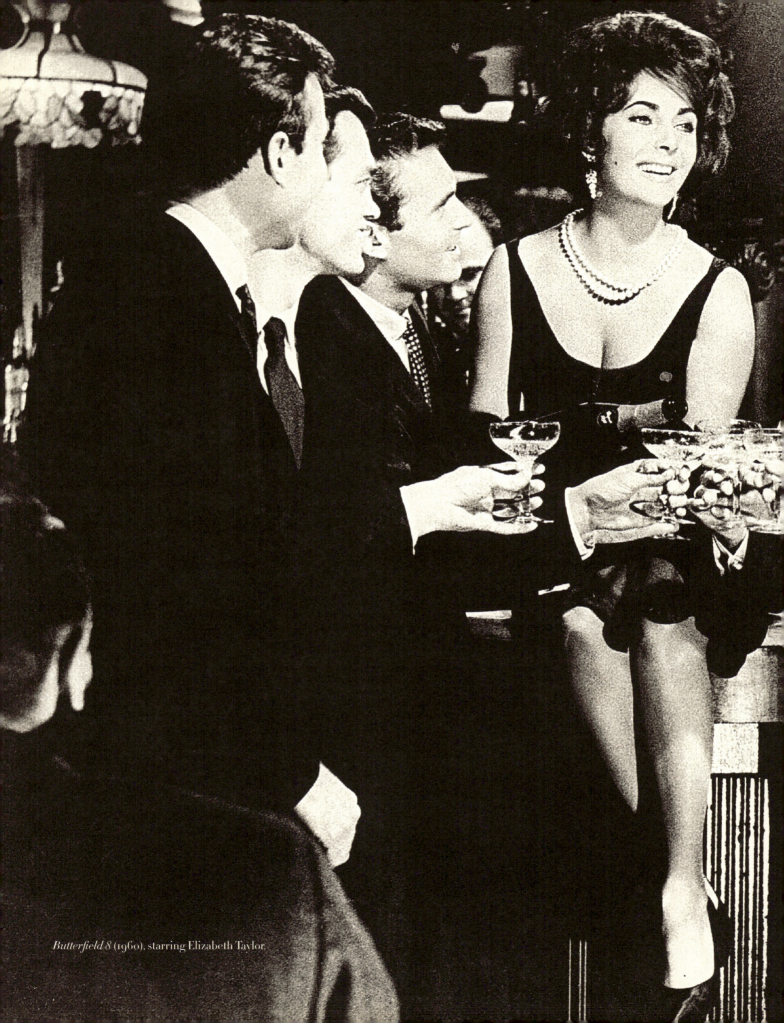

Butterfield 8 (1960), starring Elizabeth Taylor.

MINT JULEP

2 OZ. ELISAH CRAIG **BOURBON**

1/2 OZ. SIMPLE SYRUP OR A LEVEL
TEASPOON OF SUGAR

2 SPRIGS OF **MINT** GARNISH:
MINT SPRIG

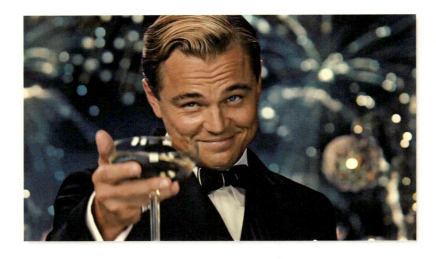

PLACE ALL INGREDIENTS INTO A MIXING GLASS, VIGOROUSLY
MUDDLE MINT UNTIL BRUISED, FILL GLASS WITH CRUSHED ICE,
DOUBLE STRAIN INTO GLASS, GARNISH AND SERVE.

Asked about the atmosphere of the Golden Globe Awards, Leonardo DiCaprio
told MTV News that "it's a lot more relaxed," but cautioned against drinking
too much: "You don't want to go above three. Two takes the edge off;
three, you're going up on stage and doing something silly." In *The Great Gatsby*
(2013), DiCaprio plays Gatsby, who drinks Mint Juleps with his friends
at the Plaza Hotel in New York on a hot summer's day.

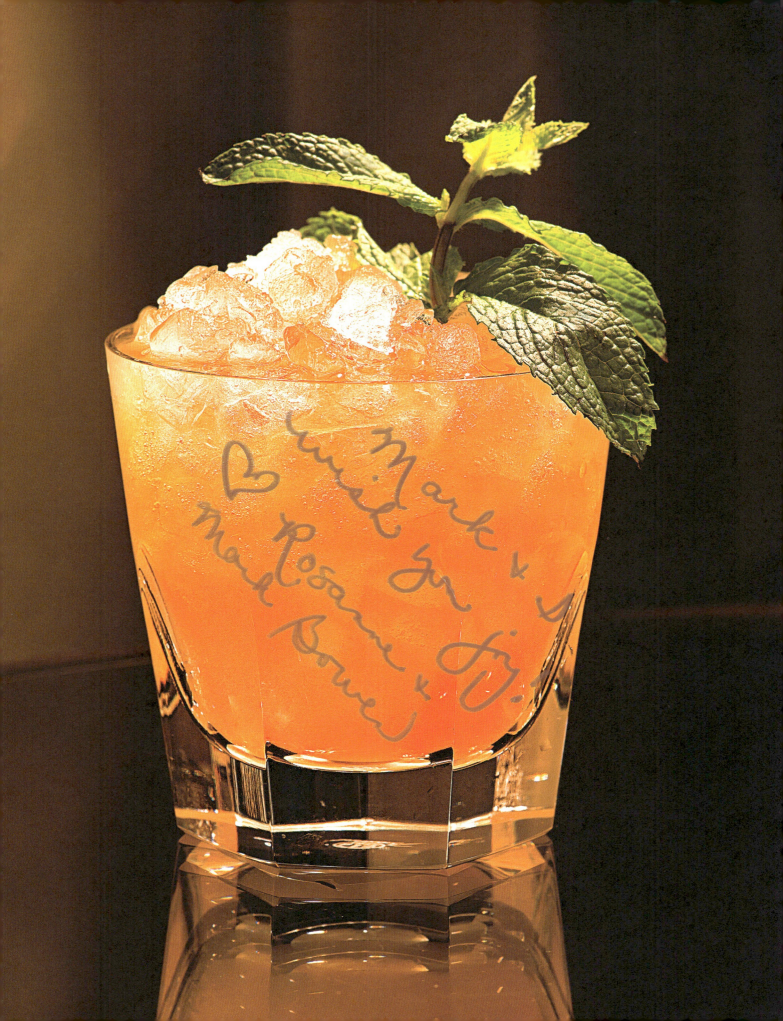

GIN SLING

1 oz. CARPANO ANTICA FORMULA SWEET VERMOUTH
1 1/2 oz. BEEFEATER GIN 3/4 oz. FRESH LEMON JUICE
1 oz. SIMPLE SYRUP 1 DASH ANGOSTURA BITTERS
1 oz. CLUB SODA GARNISH: HORSE'S NECK LEMON PEEL SPIRAL

PLACE ALL INGREDIENTS (EXCEPT CLUB SODA) INTO A MIXING TIN, ADD LARGE ICE, SHAKE VIGOROUSLY, ADD CLUB SODA, TUMBLE ROLL BACK AND FORTH ONCE, TASTE FOR BALANCE, GARNISH AND SERVE.

Ava Gardner was close to Ernest Hemingway, and the pair went drinking together around the world from Havana to Madrid. Gardner favored Beefeater Gin, which she often drank neat, although she also enjoyed classic cocktails, like the Bloody Mary, Martini, and Mai Tai.

16

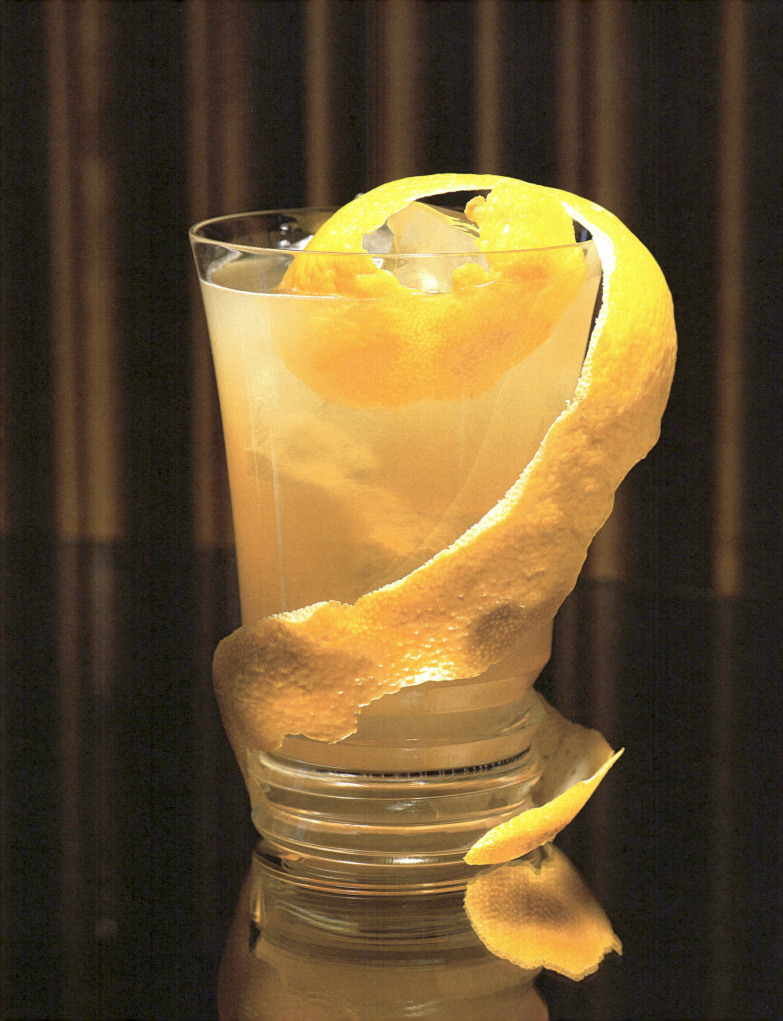

COSMOPOLITAN

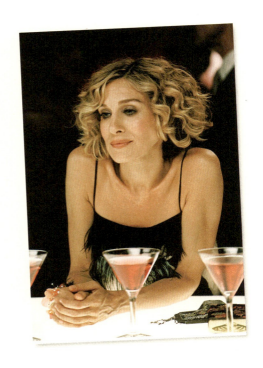

1 ½ oz. ABSOLUT CITRON VODKA

¾ oz. COINTREAU

¼ oz. FRESH LIME JUICE

1 oz. CRANBERRY JUICE

GARNISH: FLAMED ORANGE PEEL

PLACE ALL INGREDIENTS INTO MIXING TIN,
ADD LARGE ICE. **SHAKE** VIGOROUSLY,
TASTE FOR BALANCE, DOUBLE STRAIN INTO GLASS,
FLAMED ORANGE PEEL OVER THE TOP AND SERVE.

Sarah Jessica Parker as her on-screen persona, Carrie Bradshaw on the TV series
Sex and the City (1998–2004), helped to popularize the Cosmopolitan, making it a global
phenomenon. However, it was renowned mixologist Dale DeGroff who perfected the recipe
at the Rainbow Room in the late '90s. In 2008, when *Sex and the City: The Movie*
was filmed, Mrs. Parker shot a scene from the movie at Bemelmans Bar in New York's
Carlyle Hotel. As the consulting mixologist at the time, The Carlyle asked me to create
the Bradshaw Cocktail later featured in *Vintage Cocktails*.

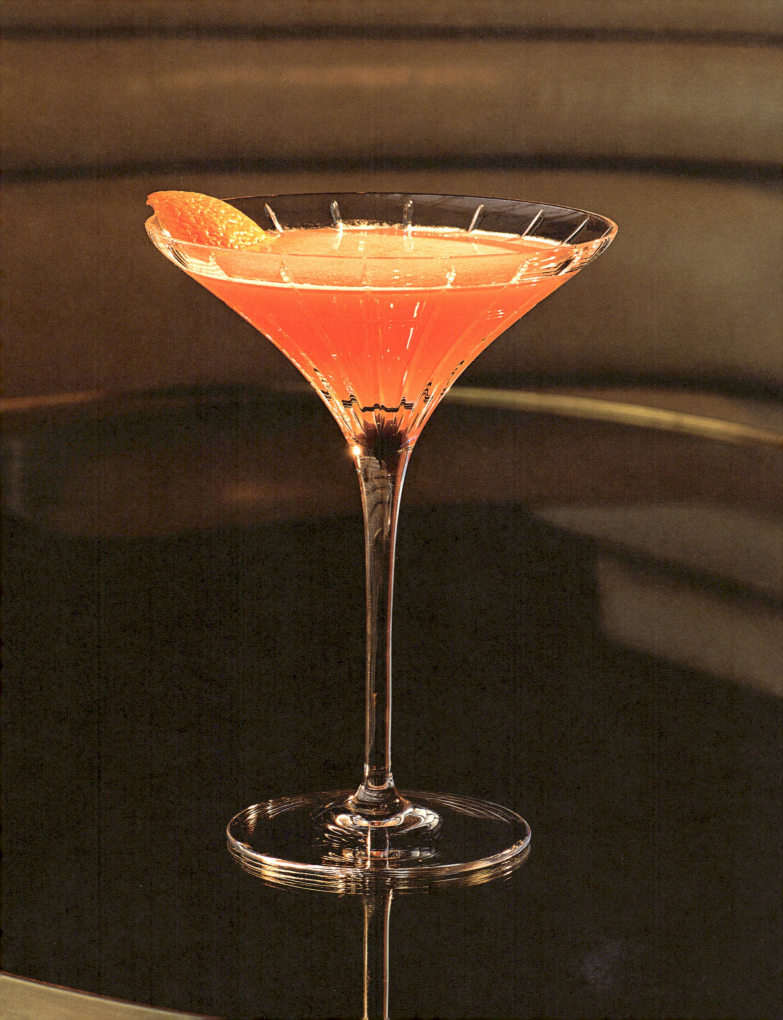

FLAMING RUM PUNCH

1 ½ oz. BACARDI LIGHT RUM

¼ oz. FRESH ORANGE JUICE

¼ oz. FRESH PINEAPPLE JUICE

¼ oz. CHERRY HEERING BRANDY

¼ oz. MONIN GRENADINE

FLOAT ½ oz. FLAMING HIGH-PROOF RUM (92% abv+)

GARNISH; RIM GLASS WITH ORANGE PEEL AND DIP IN SUGAR

ADD ALL INGREDIENTS TO A MIXING TIN AND POUR INTO TEMPERED GLASS, FLOAT THE HIGH-PROOF RUM ON TOP AND IGNITE WITH A MATCH. THE HIGH-PROOF RUM WILL PRODUCE A FLAME. SLOWLY ROTATE THE GLASS TO CARAMELIZE THE SUGAR, EXTINGUISH FLAME BY QUICKLY PLACING COCKTAIL NAPKIN OVER THE TOP OF GLASS.

In his favorite film, *It's a Wonderful Life* (1946), James Stewart played the character George Bailey, who enters Nick's Bar with his guardian-angel-in-training, Clarence. Stewart's character orders a double bourbon neat, while Clarence orders a Flaming Rum Punch, but changes his mind to a Mulled Wine, light on the clove, heavy on the cinnamon!

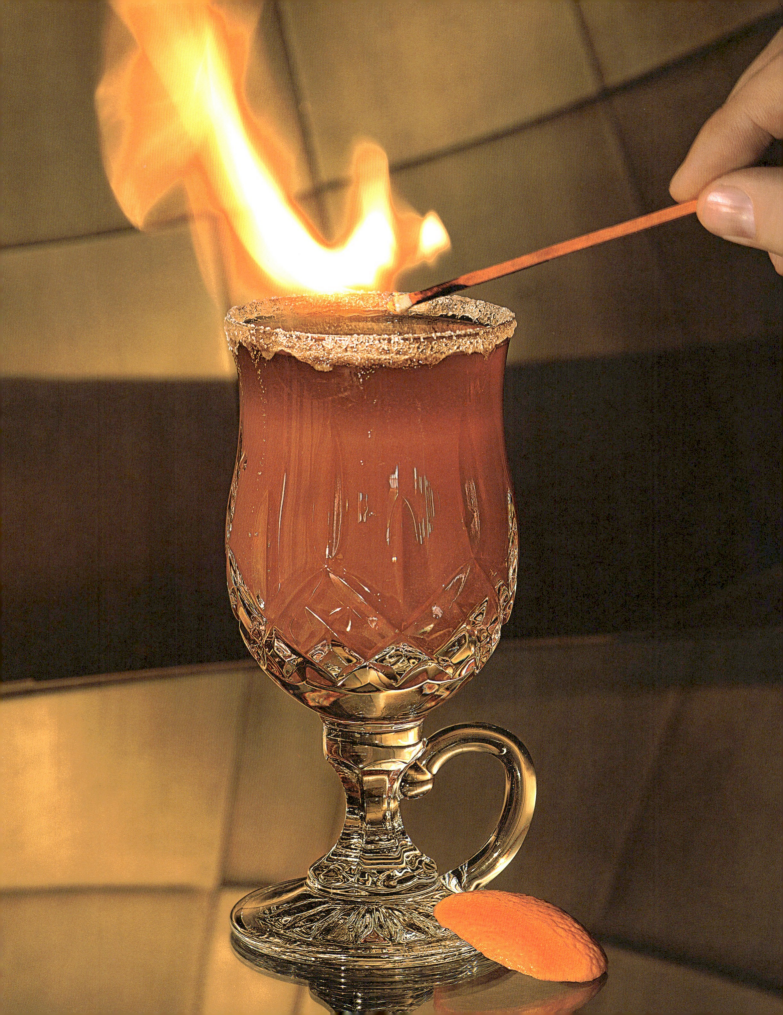

WHITE SPIDER

(VODKA STINGER)

1 ¹/₂ OZ. RUSSIAN STANDARD VODKA

3/4 OZ. WHITE CRÈME DE MENTHE

PLACE BOTH INGREDIENTS INTO A MIXING GLASS, ADD LARGE ICE, STIR THOROUGHLY, SLOWLY STRAIN OVER FRESH ICE AND SERVE.

Joan Crawford became one of Hollywood's most prominent movie stars and one of the highest-paid women in the United States, and it was rumored that at the height of her fame Crawford secretly dated a bartender who brought her Stingers.
She threw lavish parties and served punches, but the drink she preferred was vodka on the rocks.

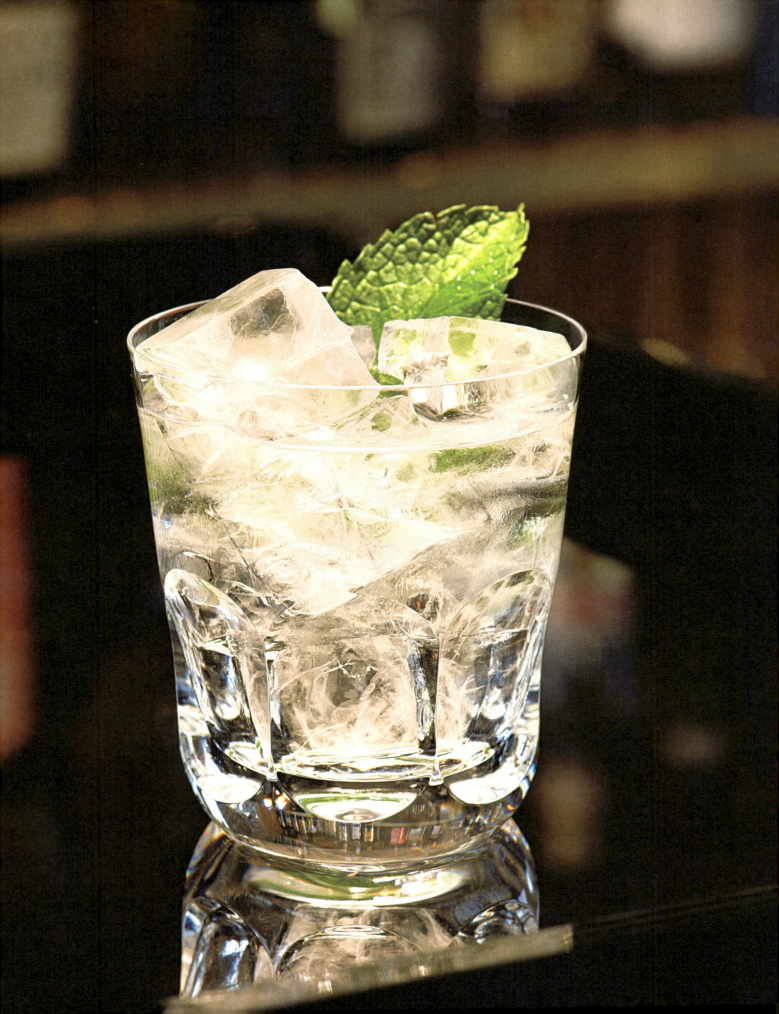

THE MOULIN ROUGE

1 oz. APRICOT BRANDY
1/2 oz ORANGE GIN
1/2 oz. LEMON JUICE
3 DASHES POMEGRANATE
GRENADINE SYRUP

GARNISH : ORANGE PEEL

PLACE ALL INGREDIENTS INTO A MIXING TIN,
ADD LARGE ICE, SHAKE VIGOROUSLY,
TASTE FOR BALANCE,
DOUBLE STRAIN INTO GLASS,
GARNISH AND SERVE

Moulin Rouge is best known as the birthplace of the cancan dance that led to the introduction of cabarets across Europe. Today, Moulin Rouge is a tourist attraction, offering musical dance entertainment for visitors from around the world. The establishment inspired the film *Moulin Rouge!* (2001), starring Nicole Kidman and Ewan McGregor. The Moulin Rouge Cocktail first appeared in print in *The Savoy Cocktail* book in 1930.

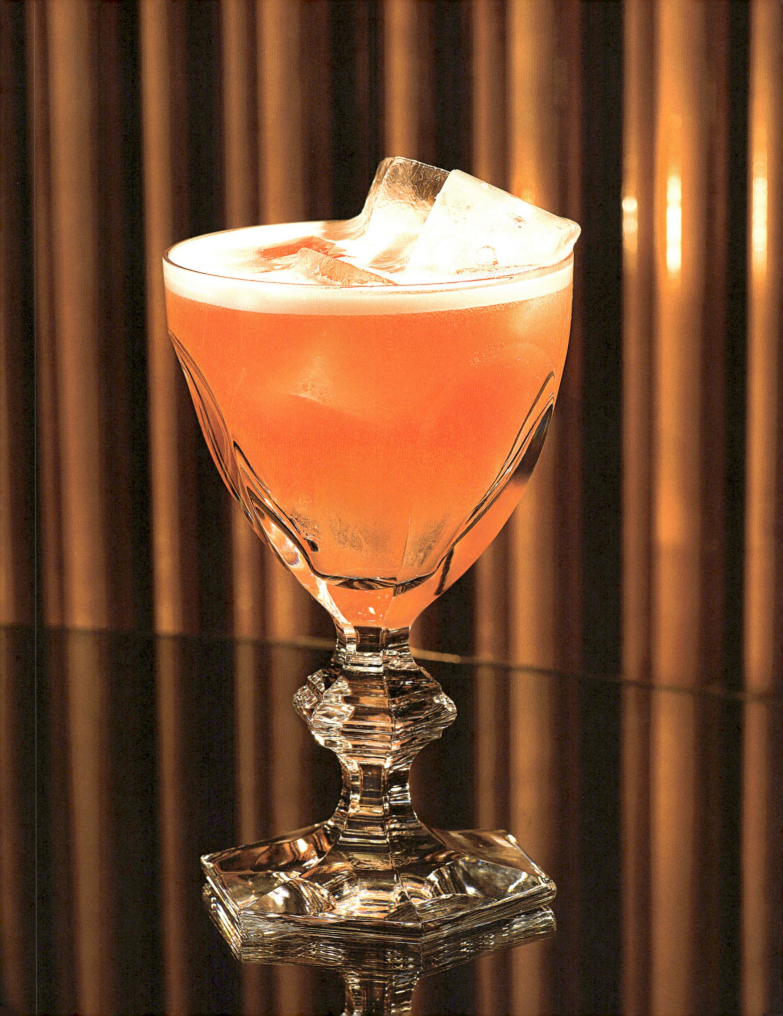

STINGER

1 ½ OZ. OF BRANDY

¾ OZ. WHITE CRÈME DE MENTHE

GARNISH: NONE (OPTIONAL: MINT LEAF)

PLACE BOTH SPIRITS INTO A MIXING GLASS AND ADD LARGE ICE. STIR THOROUGHLY, TASTE FOR BALANCE, STRAIN INTO GLASS, GARNISH AND SERVE.

Ian Fleming based the character of James Bond on Cary Grant's suave persona down to the "shaken, not stirred" Gin Martini, which was Grant's favorite drink in real life. Onscreen, Grant drank a variety of cocktails, but only one was mentioned by name in two different films. In *Kiss Them for Me* (1957) and *The Bishop's Wife* (1947), Grant's characters popularized the now classic Stinger.

26

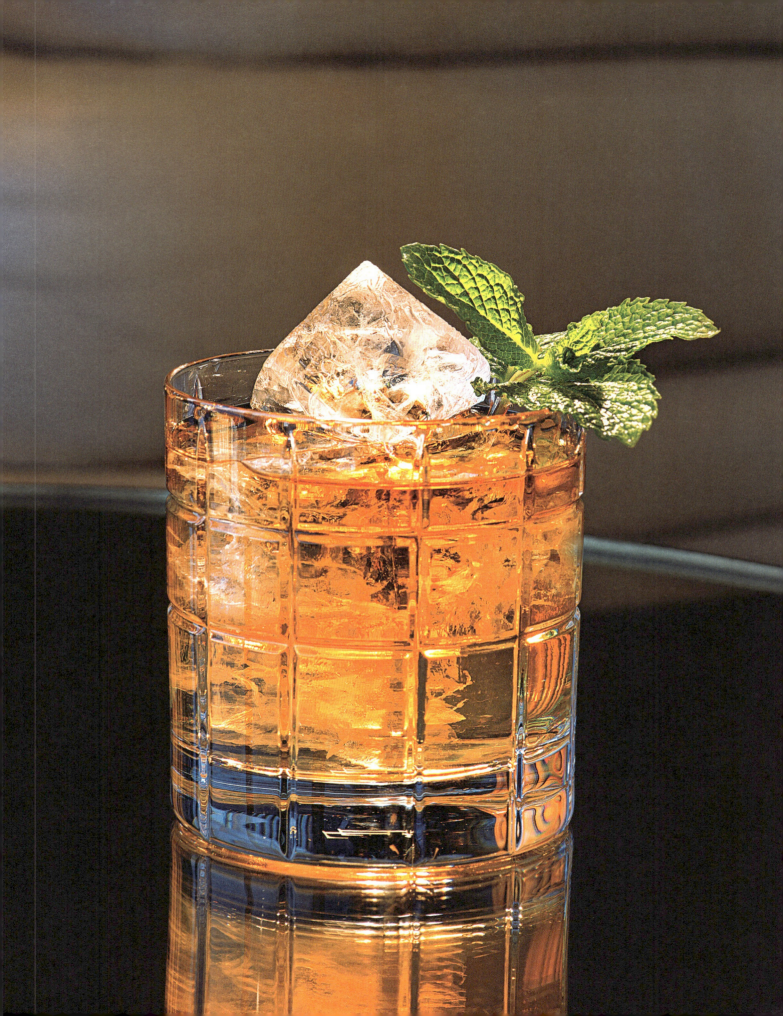

HEMINGWAY DAIQUIRI

1 oz. HAVANA CLUB WHITE RUM
1/4 oz. MARASCHINO LIQUEUR
1/2 oz. GRAPEFRUIT JUICE
3/4 oz. SIMPLE SYRUP
3/4 oz. FRESH LIME JUICE

GARNISH: MARASCHINO LIQUEUR-SOAKED MARASCHINO OR BING CHERRIES.

PLACE ALL INGREDIENTS INTO A MIXING TIN, ADD LARGE ICE, SHAKE VIGOROUSLY, TASTE FOR BALANCE, DOUBLE STRAIN INTO GLASS, GARNISH AND SERVE.

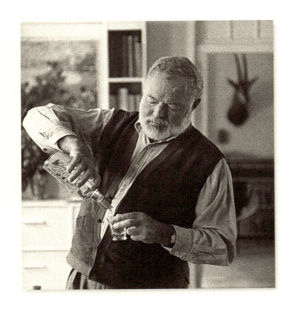

Ernest Hemingway loved to escape to Cuba during Prohibition to smoke cigars and drink rum. He particularly enjoyed the classic Daiquiri, but diabetes forced him to watch his sugar intake. In 1921, Barman Constantino Ribalaigua, of the Floridita Bar in Havana, created the Papa Doble or "Hemingway Daiquiri." The original recipe has no sugar added.

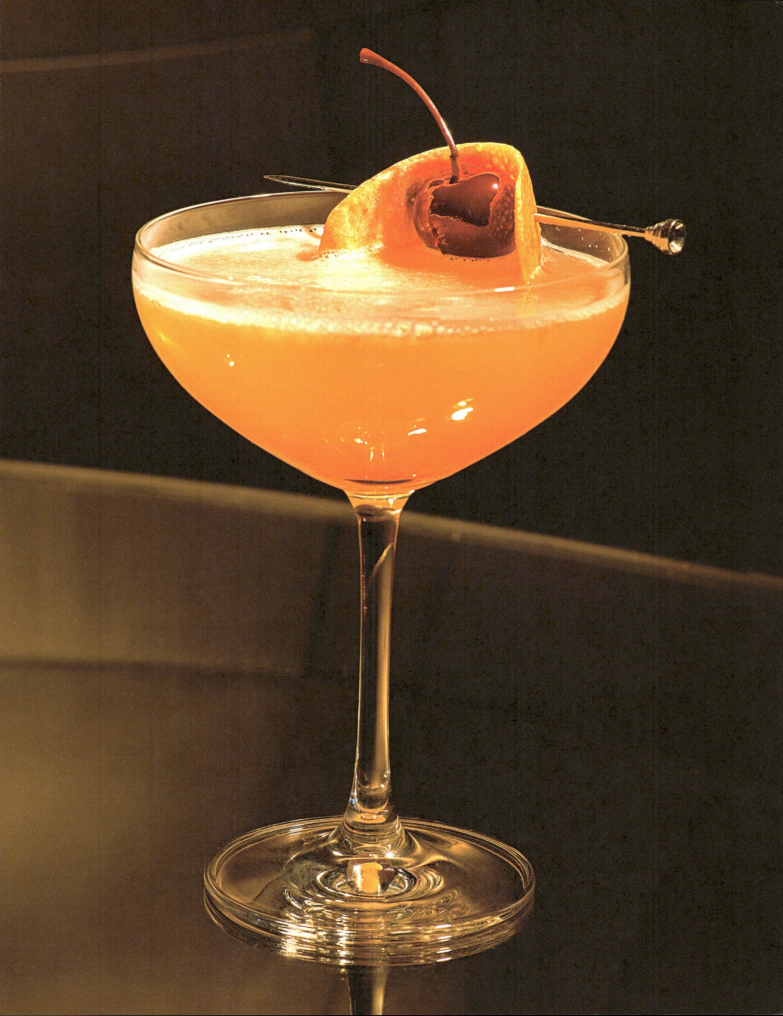

"There comes a time in every woman's life when the only thing that helps is a glass of champagne."

Bette Davis

Rachel & Brian —
congratulations and best wishes on your marriage. We loe you both and can't wait to witness all of the love and blessings in your life! —♡—Megan and Joey

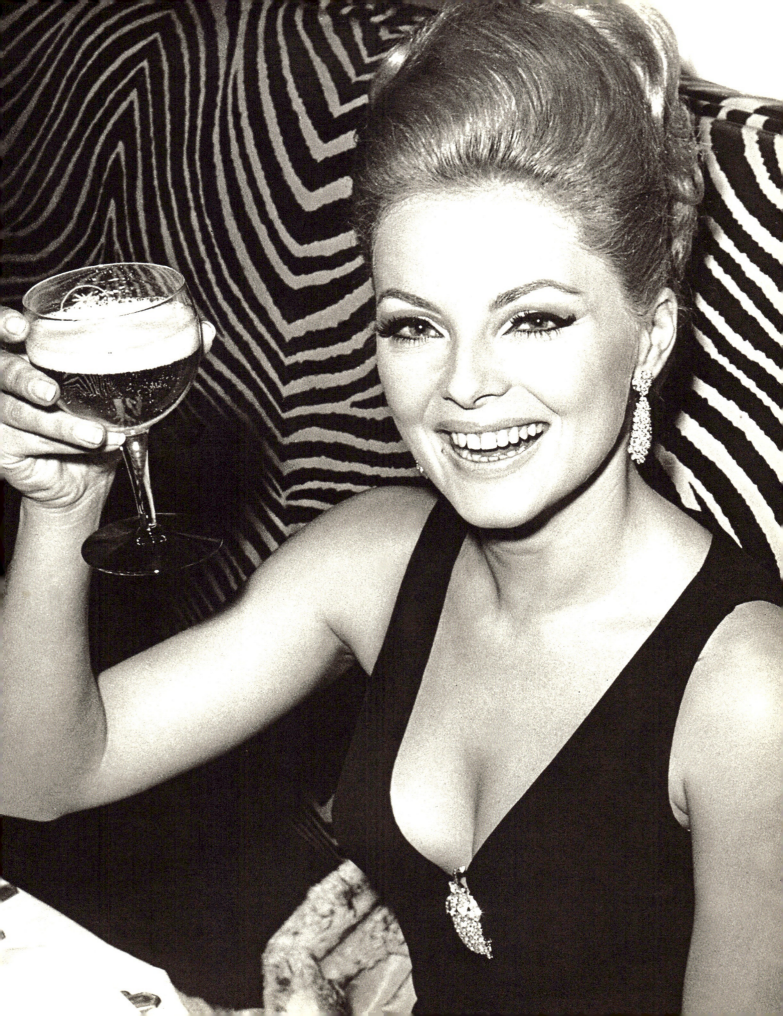

CUBA LIBRE

1 1/2 oz. HAVANA CLUB RUM
3 1/2 oz. COCA-COLA

GARNISH: FRESH LIME WEDGE

PLACE RUM INTO A MIXING GLASS.
ADD LARGE ICE, ADD COCA-COLA,
TUMBLE ROLL BACK AND FORTH ONCE,
GARNISH AND SERVE.

THE ONLY DIFFERENCE BETWEEN A RUM & COKE AND A CUBA LIBRE IS THE LITTE!

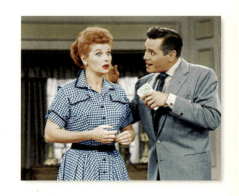

Lucille Désirée Ball met Cuban-born bandleader Desi Arnaz in 1940 while filming the Rodgers and Hart stage sensation *Too Many Girls*. The couple eloped the same year.
Even though they were only six years apart in age, it was not quite socially acceptable for an older woman to marry a younger man, so they split the difference in their ages, both claiming they were born in 1914. Desi loved Cuban rum, while Lucy preferred Jack and Coke; together...Cuba Libre!

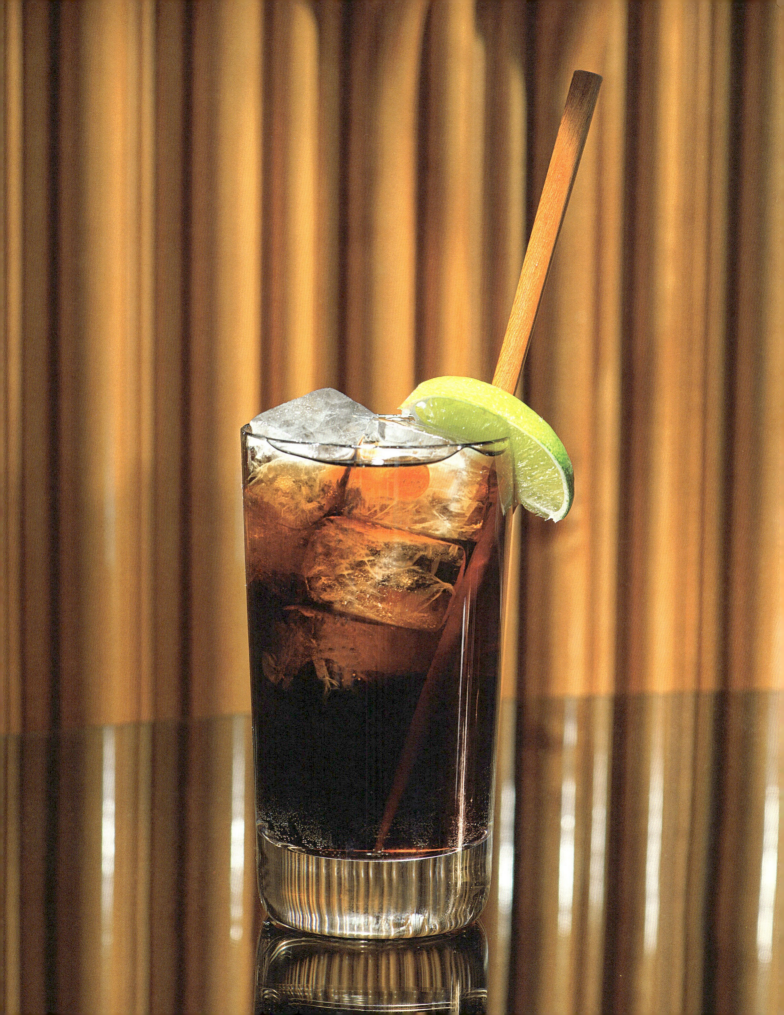

NICK & NORA

(DRY VODKA MARTINI)

2 oz. SMIRNOFF NO. 21 VODKA
NOILLY PRAT DRY VERMOUTH RINSE

GARNISH: 2 SKEWERED OLIVES

RINSE OUT NICK & NORA GLASS WITH DRY VERMOUTH. PLACE VODKA INTO A MIXING GLASS, ADD LARGE ICE AND STIR THOROUGHLY, SLOWLY POUR INTO GLASS, GARNISH AND SERVE.

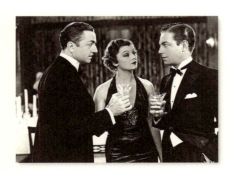

William Horatio Powell and Myrna Loy played Nick and Nora Charles, a retired detective and a socialite in *The Thin Man* (1934), who team up to solve a murder mystery in post-Prohibition Manhattan. The two characters were not only great detectives, they were also prolific drinkers: The glasses they drank from, later named after the duo, were about a third the size of the modern martini glass and became immensely popular at the time. In one scene, Nick hands Nora a drink, and she asks him how much he's had: "This will make six Martinis"— in an effort to catch up, she orders five more for herself.

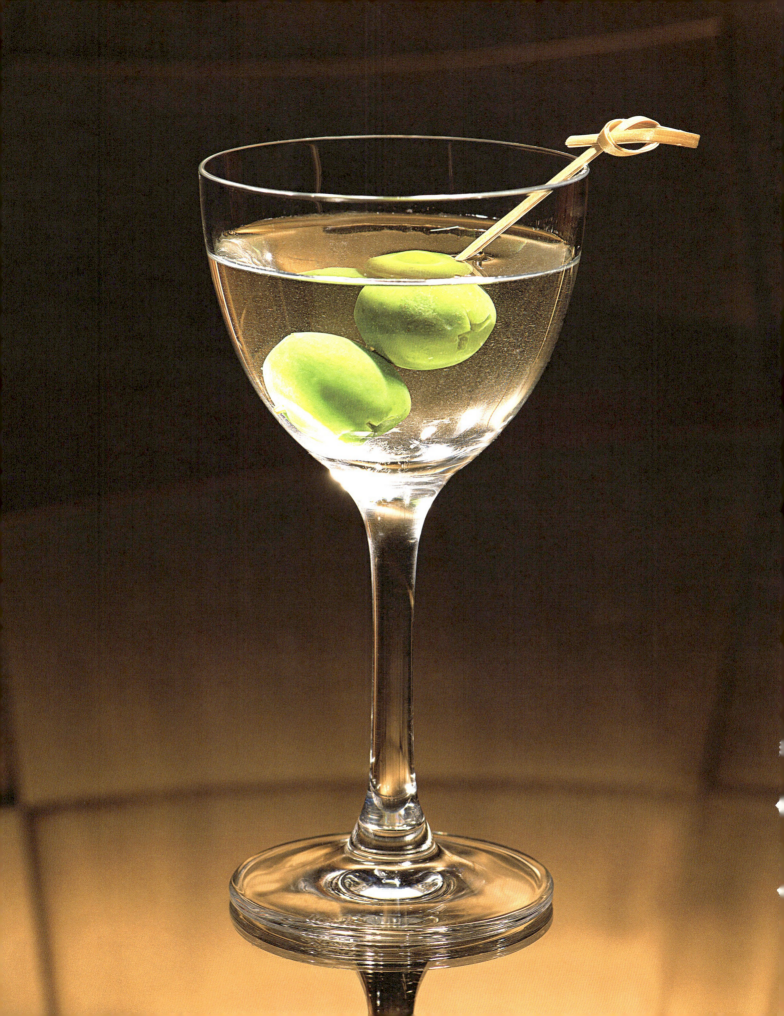

SHIRLEY TEMPLE 2014

1 1/2 oz. TITO'S VODKA
1/4 oz. MONIN GRENADINE SYRUP
1/4 oz. FRESH LIME JUICE
3 oz. GINGER BEER

GARNISH: BRANDY-SOAKED BING CHERRIES

PLACE ALL INGREDIENTS (EXCEPT GINGER BEER) INTO A MIXING GLASS, ADD LARGE ICE, SHAKE VIGOROUSLY, ADD GINGER BEER, TUMBLE ROLL ONCE, TASTE FOR BALANCE AND DOUBLE STRAIN OVER FRESH ICE, GARNISH AND SERVE.

Shirley Temple Black was often invited to parties at the famous Chasen's Bar in Beverly Hills in the 1930s. But being a child star, Temple complained that she couldn't drink like the adults, so a bartender whipped up the famous namesake drink in her honor. Later in life Temple admitted she hated the drink because it was "so sweet." Sadly, she passed away during the making of this book. This is my tribute cocktail.

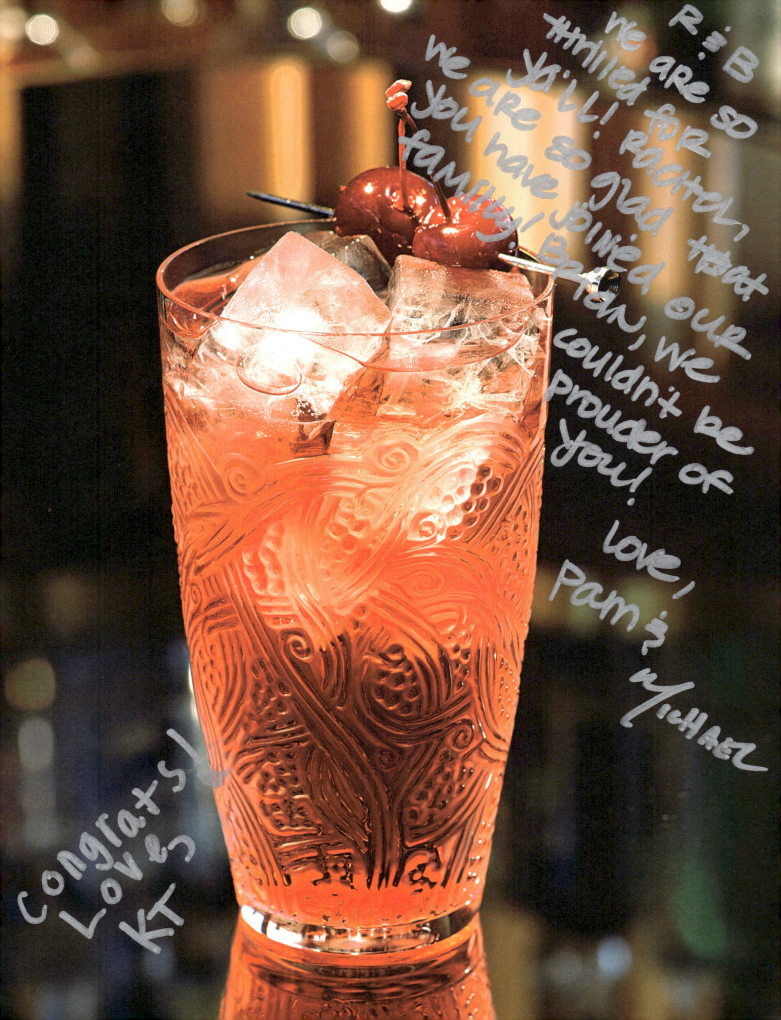

SUSPENDED GRAVITY

3 ½ oz. PIPER-HEIDSIECK CHAMPAGNE
1½ oz. RÉMY MARTIN COGNAC
2 DASHES ANGOSTURA BITTERS
1 SUGAR CUBE GARNISH: LEMON SPIRAL PEEL

SOAK A SUGAR CUBE WITH BITTERS,
PLACE SPIRAL LEMON PEEL
INSIDE CHAMPAGNE GLASS, ADD COGNAC,
ADD CHILLED CHAMPAGNE,
SLOWLY ADD SUGAR CUBE
(CAREFUL NOT TO FOAM OVER) AND SERVE.

I created this cocktail for *The Wall Street Journal* to celebrate the Academy Award-nominated film *Gravity* (2013), starring Sandra Bullock and George Clooney. The cocktail is a riff on a classic Champagne Cocktail and is designed to look like an astronaut suspended by a tether in space.

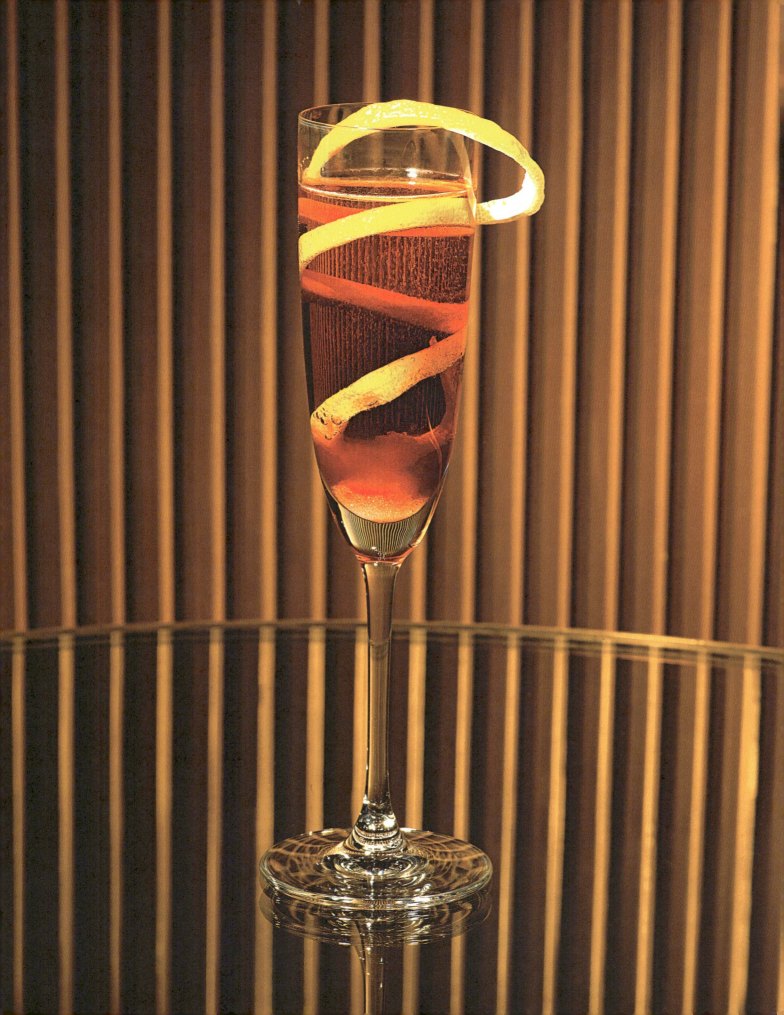

BLACKBERRY BRAMBLE

1 1/2 oz. TANQUERAY GIN

3/4 oz. FRESH LIME JUICE

3/4 oz. SIMPLE SYRUP

1/4 oz. MONIN CRÈME DE MÛRE
(BLACKBERRY LIQUEUR)

GARNISH: LIME WEDGE
BLACKBERRIES

PLACE ALL INGREDIENTS INTO A MIXING TIN,
ADD LARGE ICE, SHAKE VIGOROUSLY, TASTE FOR BALANCE,
DOUBLE STRAIN OVER CRUSHED ICE, GARNISH
AND SERVE.

W. C. Fields had a number of famous one-line quips, like, "I never drink water because of the disgusting things that fish do in it," and "Swearing off drinking is easy. I've done it a thousand times," that are still popular today. When asked if he drank to excess, he replied, "I exercise extreme self control. I never drink anything stronger than gin before breakfast." Here's a recipe I think he would have enjoyed.

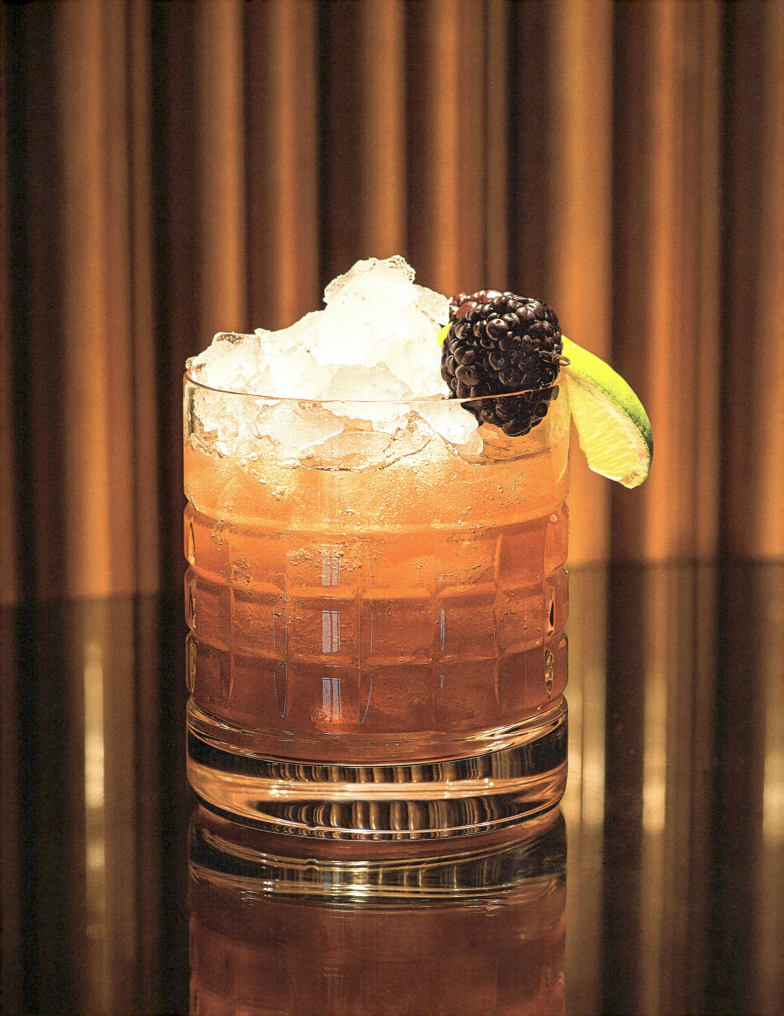

BAD BOY

1 ½ oz. EL TESORO REPOSADO TEQUILA

1 oz. LUSTAU PALO CORTADO SHERRY

½ oz. BENEDICTINE LIQUEUR

2 DASHES MOLE BITTERS

GARNISH: BRANDY-SOAKED CHERRY

PLACE ALL INGREDIENTS INTO A MIXING GLASS, ADD LARGE ICE, STIR THOROUGHLY, TASTE FOR BALANCE AND SLOWLY POUR INTO GLASS, GARNISH AND SERVE.

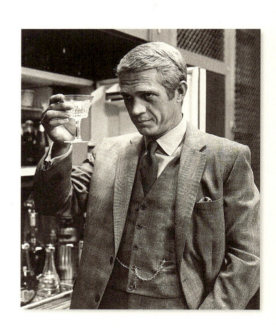

Steve McQueen was a top box-office draw of the 1960s and 1970s. Fast cars, women, and booze defined McQueen and the time. Before McQueen was discovered, he was involved in petty crimes and later joined the Marine Corps, where he was considered "rebellious"—perhaps a foreshadowing of his later combative style with Hollywood directors. McQueen enjoyed good tequila and would occasionally order a pitcher of Margaritas.

a Man's Man & a Women's Women = a great LOVE. & Marriage (in this case *forever*) Long (decades) marriages do *this*!

RAINBOW SOUR

1 oz. PINEAU DES CHARENTES

1 oz. FRAPIN VSOP COGNAC
(NOT IN ORIGINAL RECIPE)

1 oz. ROTHMAN & WINTER ORCHARD
APRICOT LIQUEUR

3/4 oz. LEMON JUICE

1/2 oz. SIMPLE SYRUP

GARNISH: ORANGE SLICE AND BRANDY-SOAKED CHERRY

PLACE ALL INGREDIENTS INTO A MIXING GLASS,
ADD LARGE ICE, SHAKE VIGOROUSLY,
TASTE FOR BALANCE, DOUBLE STRAIN OVER FRESH ICE,
GARNISH AND SERVE.

A New York City landmark, the Rainbow Room is located at the Top of 30 Rockefeller Center. It opened immediately after the repeal of Prohibition in 1934. Since then it has hosted countless celebrities including Gene Kelly, Louis Armstrong, Barbra Streisand, and Elizabeth Taylor; King Cocktail, Dale DeGroff, once worked there. After five years of renovations, it is set to reopen in the fall of 2014.

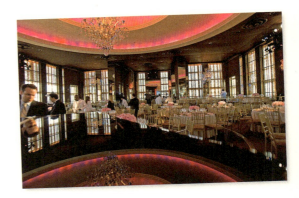

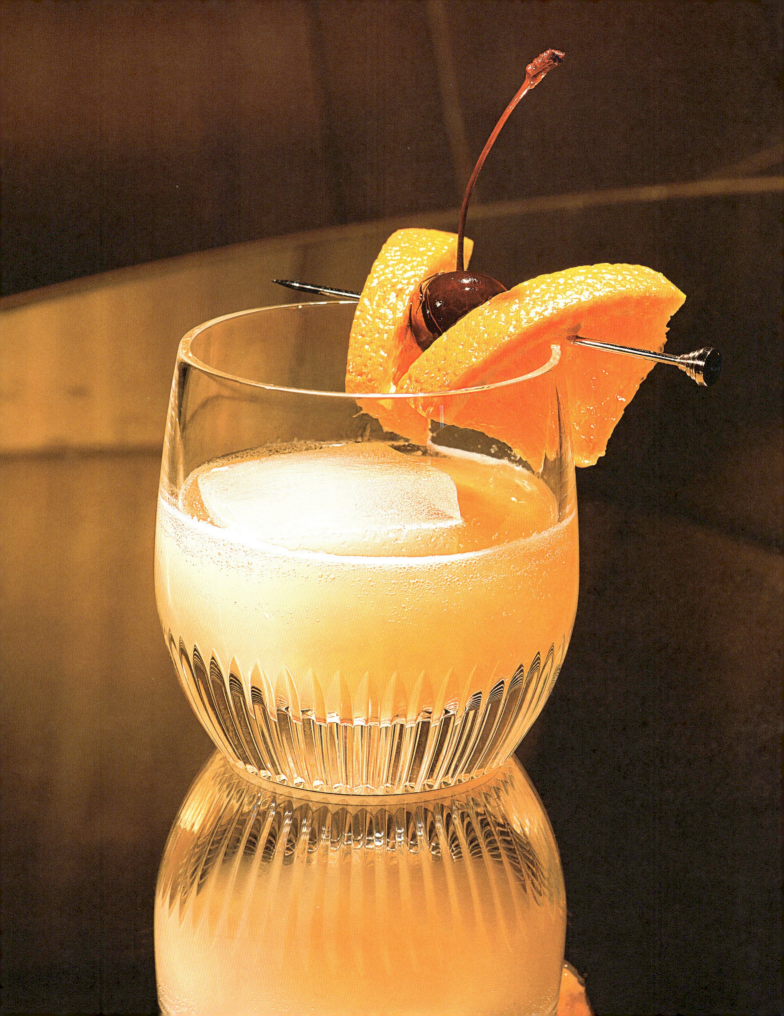

RAT PACK MANHATTAN

1 1/2 OZ. MAKER'S MARK BOURBON
1/2 OZ. GRAND MARNIER
3/4 OZ. MARTINI ROSSO
3/4 OZ. MARTINI EXTRA DRY
3 DASHES ANGOSTURA BITTERS

GARNISH: ORANGE ZEST TWIST & MARASCHINO CHERRY

PLACE ALL INGREDIENTS INTO A MIXING GLASS, ADD LARGE ICE AND STIR THOROUGHLY, TASTE FOR BALANCE, SLOWLY POUR INTO GLASS, GARNISH AND SERVE.

With her husky voice and sultry looks, Lauren Bacall emerged as a leading lady in numerous Humphrey Bogart films, becoming his fourth wife in 1945. She and Bogart loved to entertain, and while Bogart and his drinking friends referred to themselves as The Freeloaders Club, it was Bacall who said, "You look like a goddamn rat pack!"

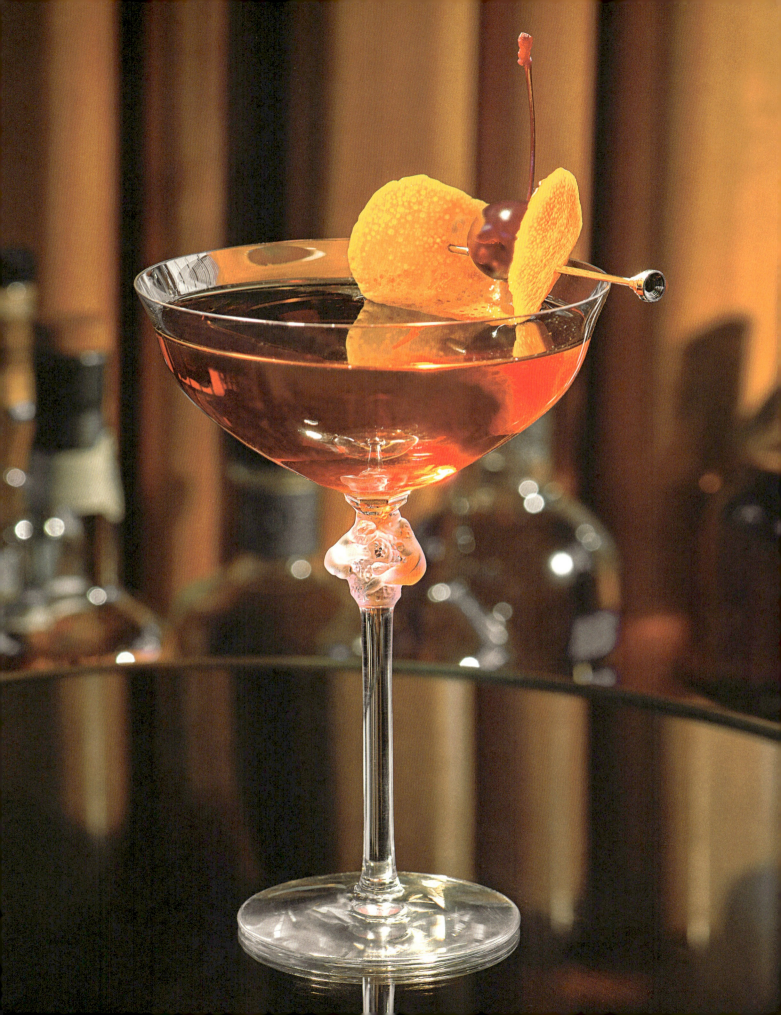

"Is the glass half full or half empty? It depends on whether you're pouring or drinking."

Bill Cosby

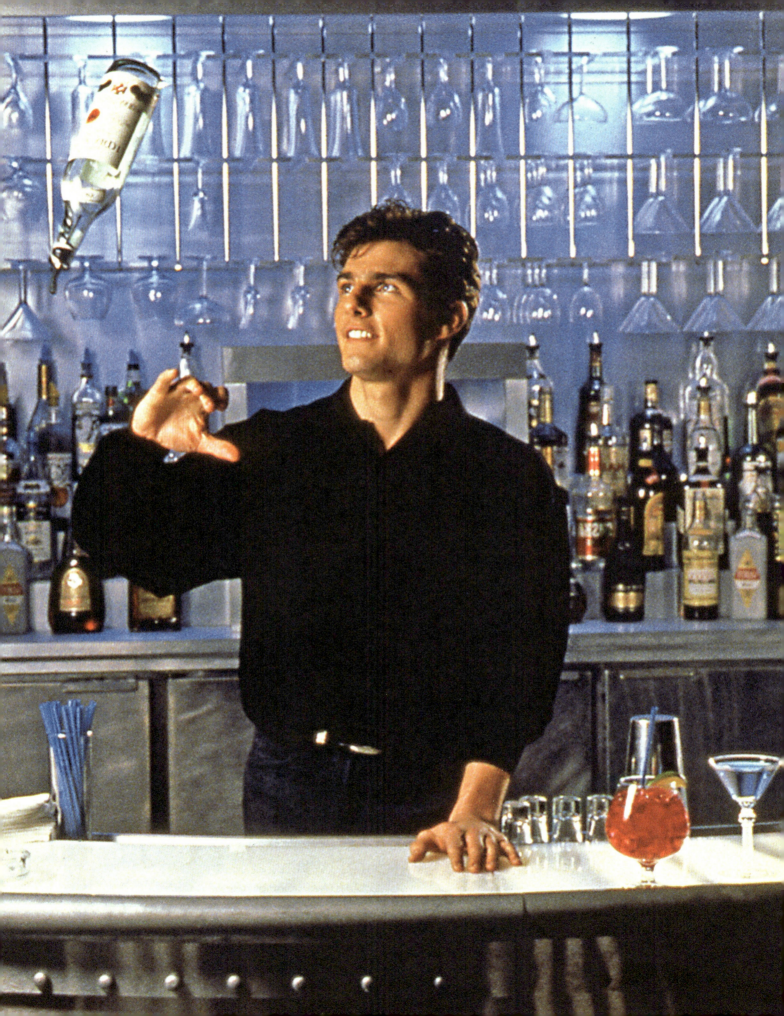

VESPER MARTINI

3 MEASURES OF GORDON'S GIN
1 MEASURE OF SMIRNOFF VODKA
½ MEASURE OF KINA LILLET

GARNISH: LEMON TWIST

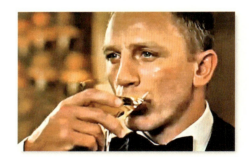

PLACE ALL INGREDIENTS INTO A MIXING GLASS, ADD LARGE ICE, STIR THOROUGHLY, TASTE FOR BALANCE, SLOWLY POUR INTO GLASS, GARNISH AND SERVE.

Daniel Craig's version of James Bond in the most recent Bond films prefers the Vesper Martini, as it is the one that he claims to have invented in *Casino Royale* (2006). I was overjoyed to serve Daniel Craig at Per Se when he came in with Ian Fleming's daughter to study for the role of Bond. He ordered one of my house-made tonics with gin ("the best [he'd] ever had") and she ordered a Vodka Martini. Even though I knew better, I had to ask: "Shaken or stirred?" For the record: A proper Martini is traditionally always stirred, but who is going to argue with a man with a license to kill?

EGGNOG PUNCH

6 EGGS, SEPARATED
1/2 CUP SIMPLE SYRUP
1/4 CUP GRANULATED SUGAR
1 FRESH VANILLA BEAN

6 oz. THE REAL MCCOY RUM 15 Yr.
6 oz. RÉMY MARTIN V.S.O.P. COGNAC
1 QUART HALF AND HALF MILK
1 PINT CREAM

GARNISH: FRESHLY GROUND NUTMEG

CUT VANILLA BEAN IN HALF AND SCRAPE CONTENTS INTO BOWL, WHISK THE EGG YOLKS UNTIL THOROUGHLY MIXED, ADD LIQUOR, SUGAR, SYRUP, AND MILK ONE AT A TIME WHILE STIRRING. SEPARATELY WHISK GRANULATED SUGAR INTO THE EGG WHITES UNTIL THEY PEAK, FOLD WHITES INTO MIXTURE, GARNISH AND SERVE.

In Britain, the Eggnog was popular mainly among the aristocracy who could afford to mix milk and eggs with brandy, Madeira, or sherry. One of the most recognized names of Hollywood, Marilyn Monroe, reportedly drank a cup of Eggnog each night before bed.

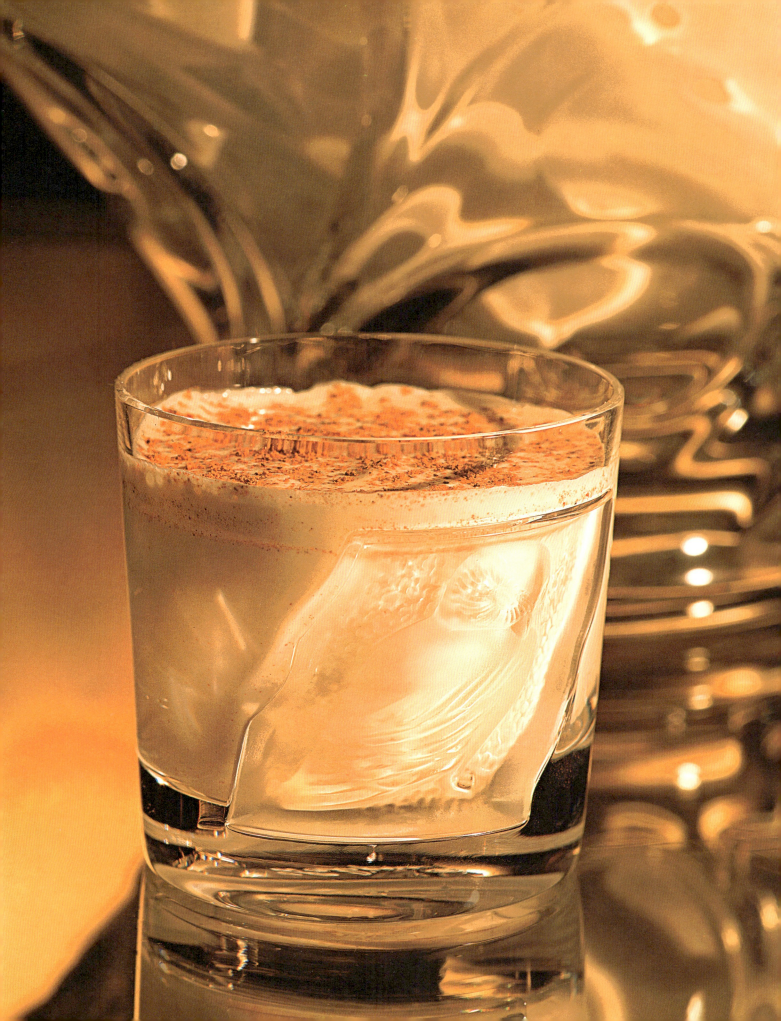

DRY GIN GIBSON

2 3/4 oz. GORDON'S GIN
1/4 oz. MARTINI & ROSSI DRY VERMOUTH

GARNISH: CIPOLLINE COCKTAIL ONIONS

PLACE INGREDIENTS IN A MIXING GLASS, ADD LARGE ICE AND STIR THOROUGHLY, SLOWLY POUR INTO GLASS, GARNISH AND SERVE.

In 1957 Edward G. Robinson did an ad campaign with Heublein Liquor Distributors as "Dr. Martini." The slogan: "If a man wants a Martini, don't force something else on him. Serve Martinis—Martinis you can be proud of!" Interestingly enough, the vodka he was referring to was America's first, Smirnoff.

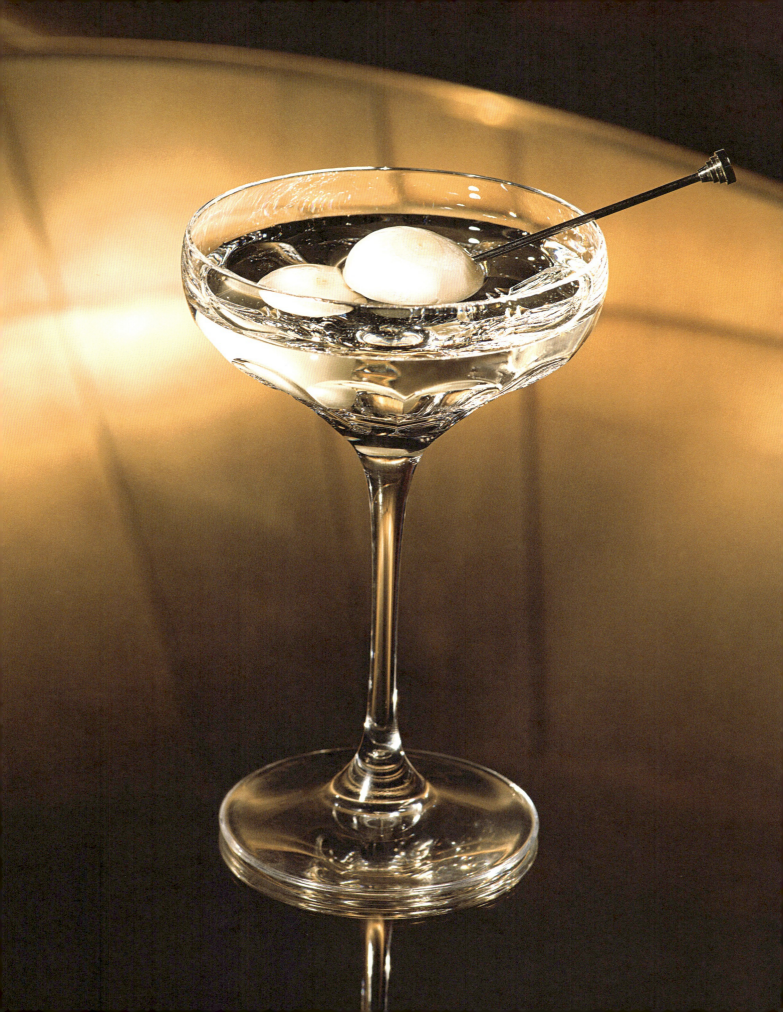

THE ORIGINAL
OLD FASHIONED
(Brandy)

2 OZ. ~~OLD GRAND-DAD WHISKEY~~

1 SUGAR CUBE

2 DASHES OF ANGOSTURA BITTERS

1 LARGE ICE CUBE OR SPHERE

GARNISH : LEMON PEEL SQUARE

PLACE ALL INGREDIENTS INTO A MIXING GLASS,
MUDDLE SUGAR CUBE UNTIL DISSOLVED,
ADD LARGE ICE, STIR THOROUGHLY,
TASTE FOR BALANCE, SLOWLY STRAIN
OVER AN ICE SPHERE AND SERVE.

Gary Cooper was known for his charming, everyman demeanor, and was extremely
versatile and crossed many film genres. In one of the many Westerns he starred in,
Dallas (1950), Cooper plays Colonel Reb Hollister, who masquerades as a US Marshal
who prefers to drink Old Grand-Dad Whiskey.

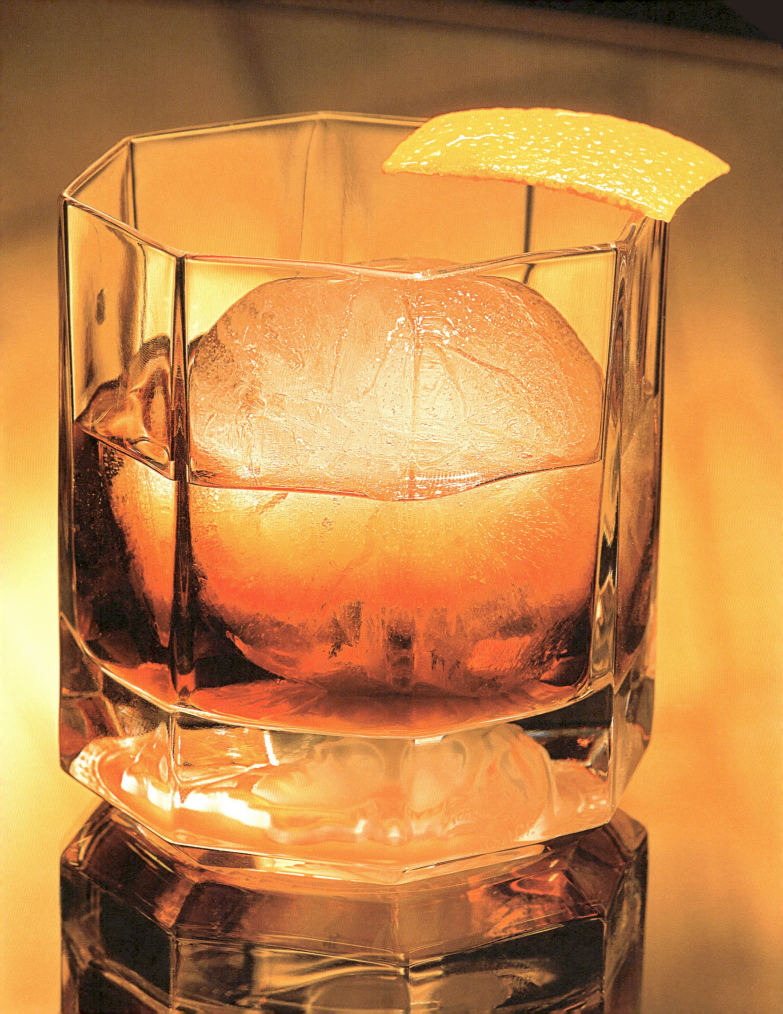

BLACK VELVET

4 oz. GUINNESS STOUT
4 oz. DRY BRUT CHAMPAGNE

STACK PINT GLASS 50%
FULL WITH GUINNESS
AND THEN SLOWLY ADD CHAMPAGNE
ON TOP OVER THE BACK OF A BAR
SPOON; TAKE CARE NOT TO
FOAM OVER.

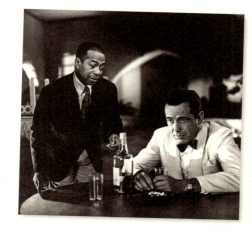

Humphrey Bogart was known for frequenting late-night speakeasies during Prohibition. Before his big break as an actor, he was said to hustle chess for a dollar a game in New York to pay his bar tabs. Bogart once said, "The problem with the world is that everyone is a few drinks behind." He loved Scotch, but often ordered Black Velvet cocktails popularized in the UK.

THE WHITE LADY

1 ½ oz. BEEFEATER 24 GIN
¾ FRESH LEMON JUICE
1 oz. COINTREAU
1 EGG WHITE

GARNISH: ORANGE HORSE-HEAD TWIST

PLACE ALL INGREDIENTS INTO A MIXING-TIN, ADD LARGE ICE, SHAKE VIGOROUSLY, TASTE FOR BALANCE, STRAIN INTO COUPE, GARNISH AND SERVE.

Harry MacElhone from Harry's Bar in Venice, Italy, invented the White Lady just after the First World War. The recipe was first printed courtesy of Harry Craddock in *The Savoy Cocktail Book* (1930). Master of suspense, director Alfred Hitchcock liked to drink White Lady cocktails, and frequented Harry's Bar when in Venice.

60

WHITE RUSSIAN

1 oz. PURITY VODKA

1 oz. KAHLUA

1 oz. HEAVY CREAM

PLACE ALL INGREDIENTS INTO A MIXING TIN, ADD LARGE ICE, SHAKE VIGOROUSLY, DOUBLE STRAIN OVER FRESH ICE, AND SERVE.

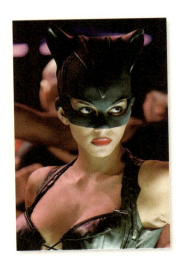

The White Russian cocktail was immortalized in Hollywood history in the 1998 cult classic, *The Big Lebowski,* where "the Dude" (played by Jeff Bridges) is seen drinking or holding nine White Russians throughout the movie.

In her 2004 role as Catwoman, Halle Berry also orders a White Russian: "...no ice, no vodka, hold the Kahlua!"

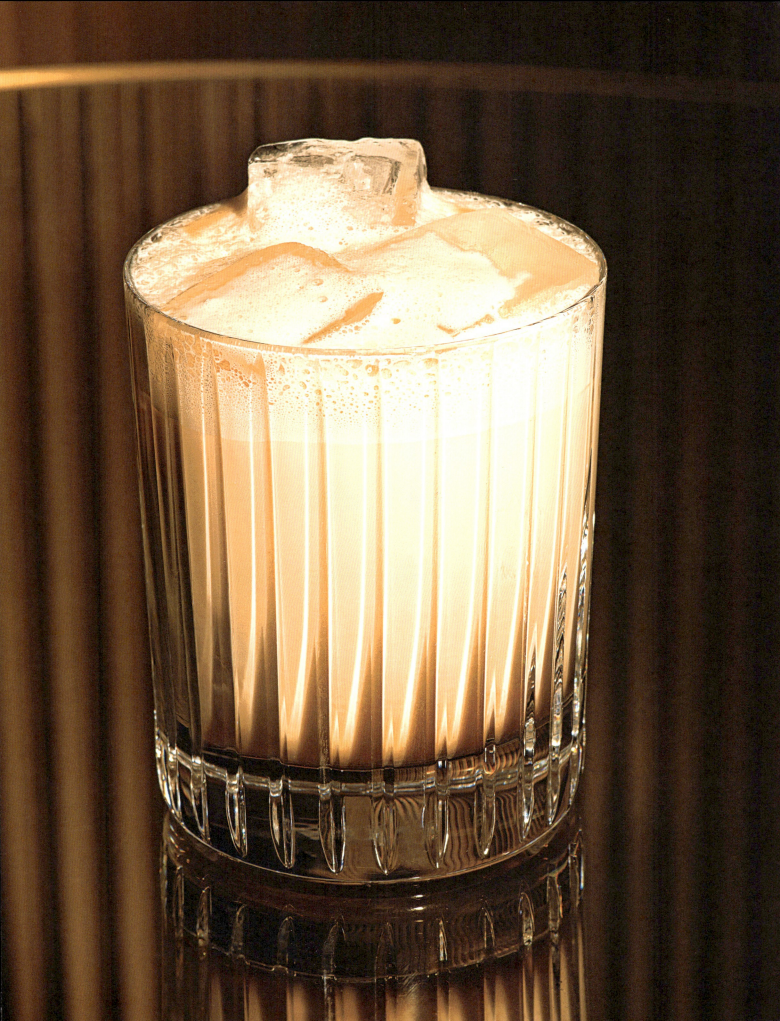

CHAMPAGNE PASSION

1¼ oz. PASSION FRUIT PURÉE

¼ oz. SIMPLE SYRUP

4 oz. CHAMPAGNE

½ oz. ALIZÉ (PASSION FRUIT) LIQUEUR

POUR THE PASSION FRUIT PURÉE INTO A MIXING GLASS, STIR IN SIMPLE SYRUP, ADD LARGE ICE, SLOWLY ADD CHAMPAGNE WHILE CONTINUING TO STIR, TASTE FOR BALANCE, STRAIN INTO FLUTE, FLOAT ALIZÉ ON TOP, SERVE.

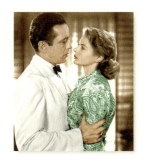

Industrialist Howard Hughes once bought every available seat on flights from New York to Los Angeles to be sure Ingrid Bergman would accept a ride in his private plane. Alfred Hitchcock reportedly also had a crush on Bergman, who played an exceptional drunk driver in his masterpiece *Notorious* (1946), while in *Casablanca* (1942) Bergman played a character that only drank Champagne.

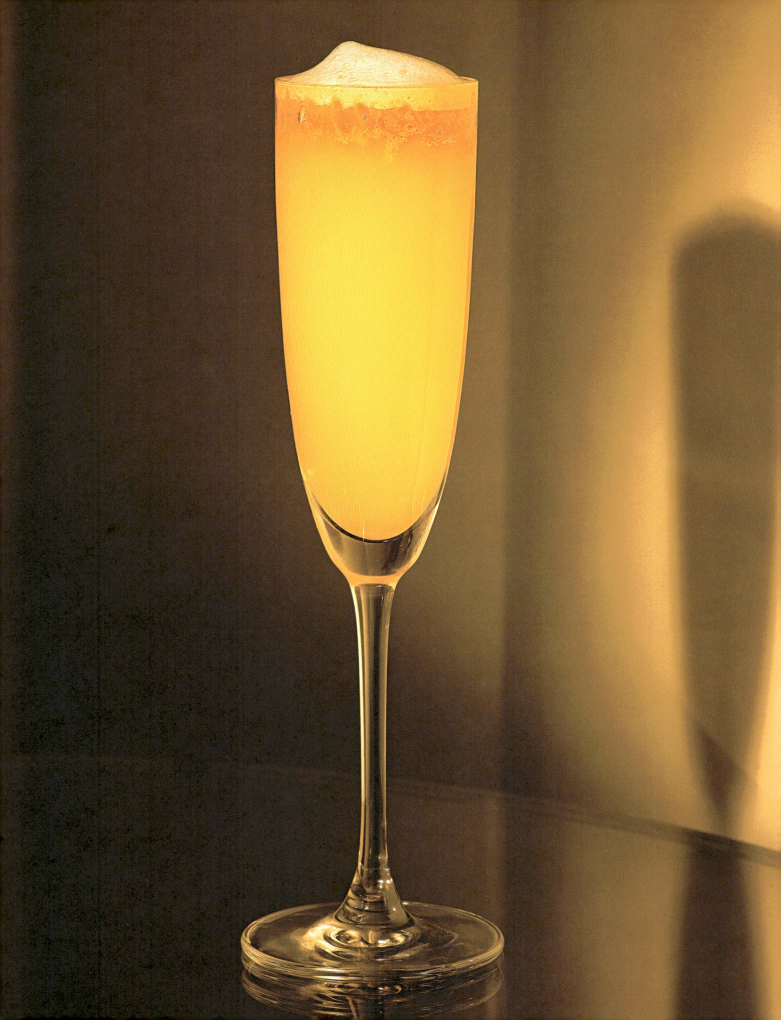

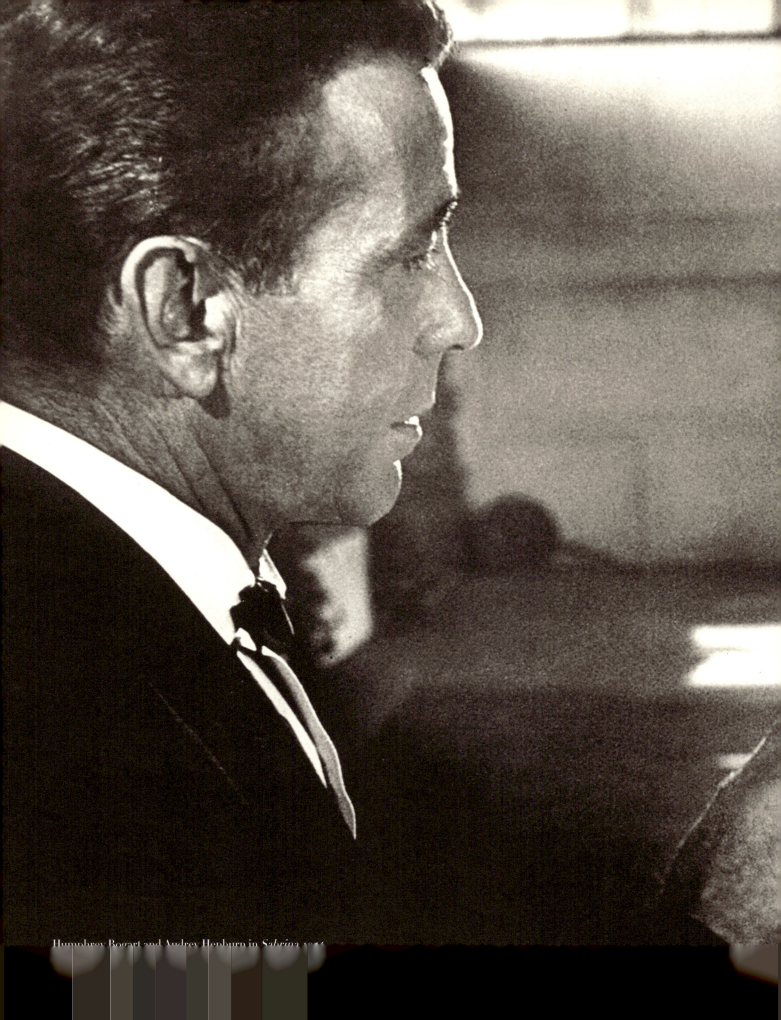

Humphrey Bogart and Audrey Hepburn in *Sabrina*, 1954

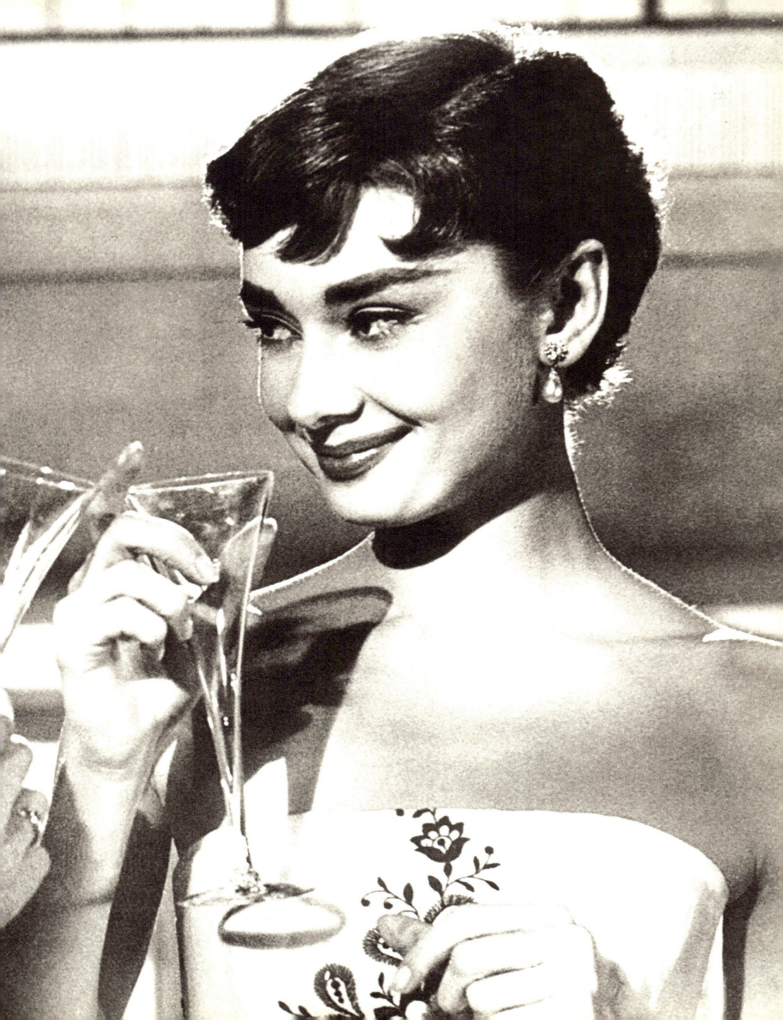

CUCKOO'S NEST

2 oz. WOODFORD RESERVE WHISKEY
1/4 oz. ABSINTHE RINSE
2 DASHES ANGOSTURA BITTERS

GARNISH: AGAVE NECTAR WITH A POPPY SEED RIM AND LEMON PEEL

COAT INSIDE OF GLASS WITH ABSINTHE AND DISCARD EXCESS, RIM GLASS WITH AGAVE NECTAR AND THEN DIP INTO POPPY SEEDS, PLACE WHISKEY AND BITTERS INTO A MIXING GLASS, ADD LARGE ICE AND STIR THOROUGHLY, TASTE FOR BALANCE, SLOWLY POUR INTO GLASS OVER ONE LARGE CUBE AND SERVE.

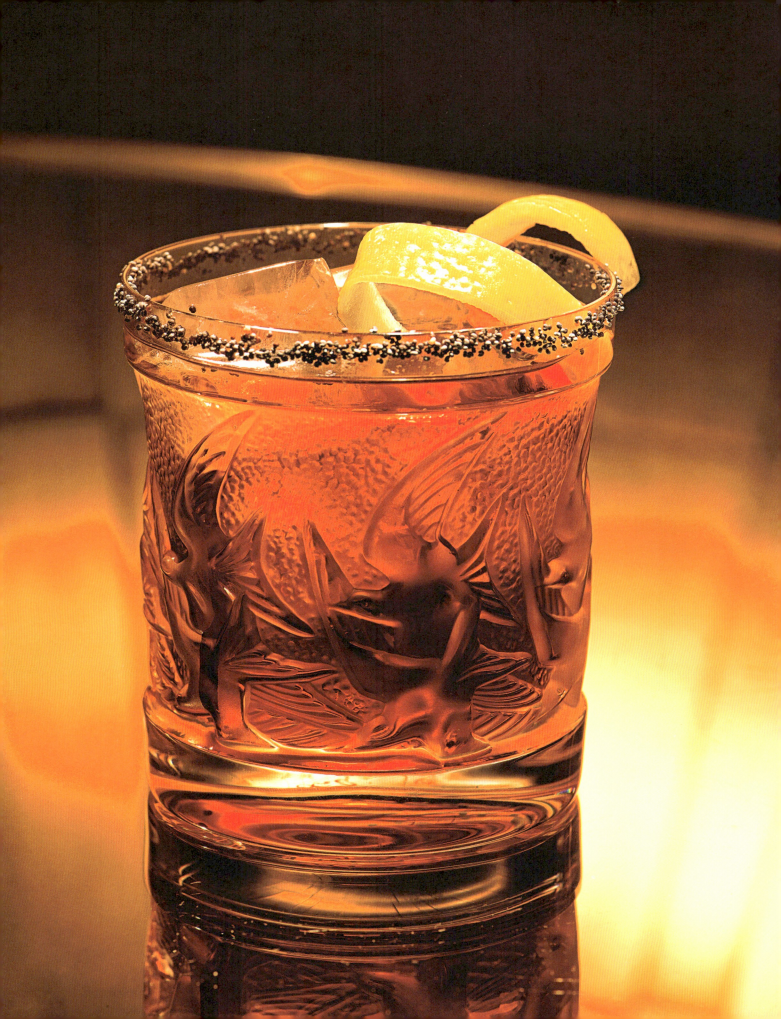

THE MARY PICKFORD

2 oz. BACARDI LIGHT RUM

1 1/2 oz. FRESH PINEAPPLE JUICE

1 tsp. MONIN GRENADINE SYRUP

1/4 oz. LUXARDO MARASCHINO LIQUEUR

PLACE ALL INGREDIENTS INTO A MIXING GLASS, ADD LARGE ICE, SHAKE VIGOROUSLY, TASTE FOR BALANCE, DOUBLE STRAIN INTO GLASS AND SERVE.

Mary Pickford was one of the Canadian pioneers in early Hollywood and a significant figure in the development of film acting. Queen of the silent movie, she had a cocktail—the Mary Pickford—named after her when she was staying in Havana with her husband, Douglas Fairbanks, in the 1920s.

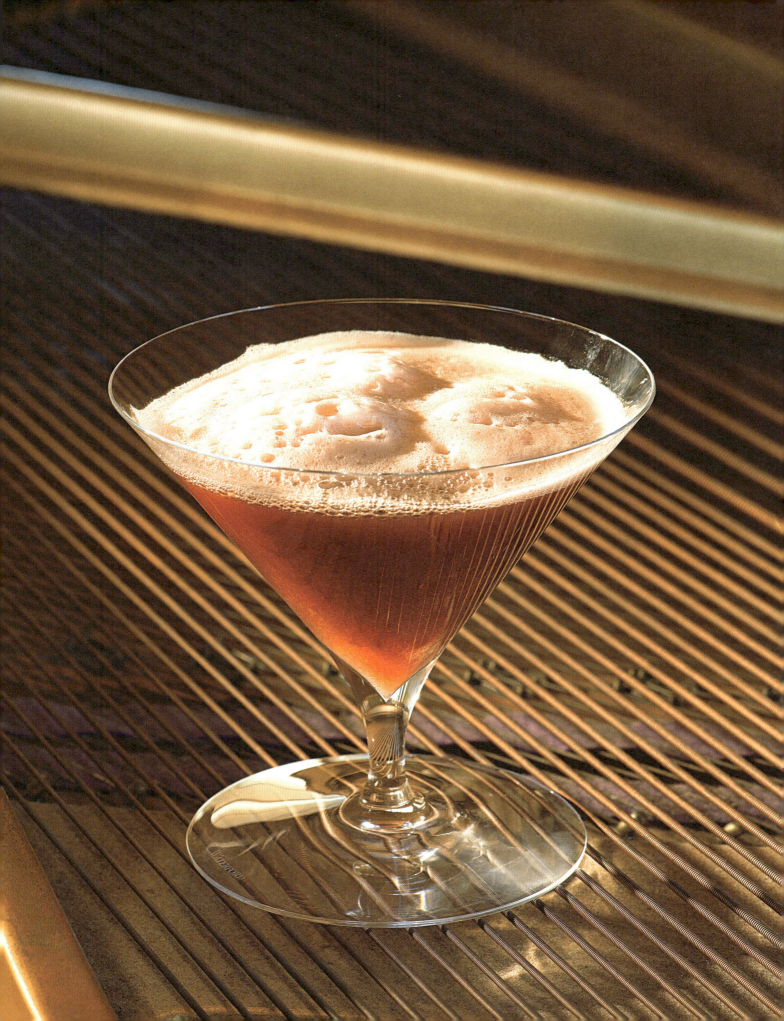

GIN & TONIC

1 1/2 OZ. TANQUERAY GIN
3 1/2 OZ. SEAGRAM'S
INDIAN TONIC WATER

GARNISH : LIME WEDGE

ADD GIN TO A HIGHBALL OR CHIMNEY GLASS.
ADD LARGE ICE TO GLASS AND FILL TO
THE TOP WITH TONIC WATER. TUMBLE ROLL
BACK AND FORTH ONCE, GARNISH AND SERVE.

Clark Gable was great friends with actress Hattie
McDaniel, who played the character Mammy in *Gone
with the Wind* (1939), and even slipped her an
alcoholic drink during the scene in which their
characters were celebrating the birth of Scarlett
and Rhett's daughter. In real life, Gable was known
to enjoy American whiskey, but his favorite drink
was a refreshing Gin & Tonic.

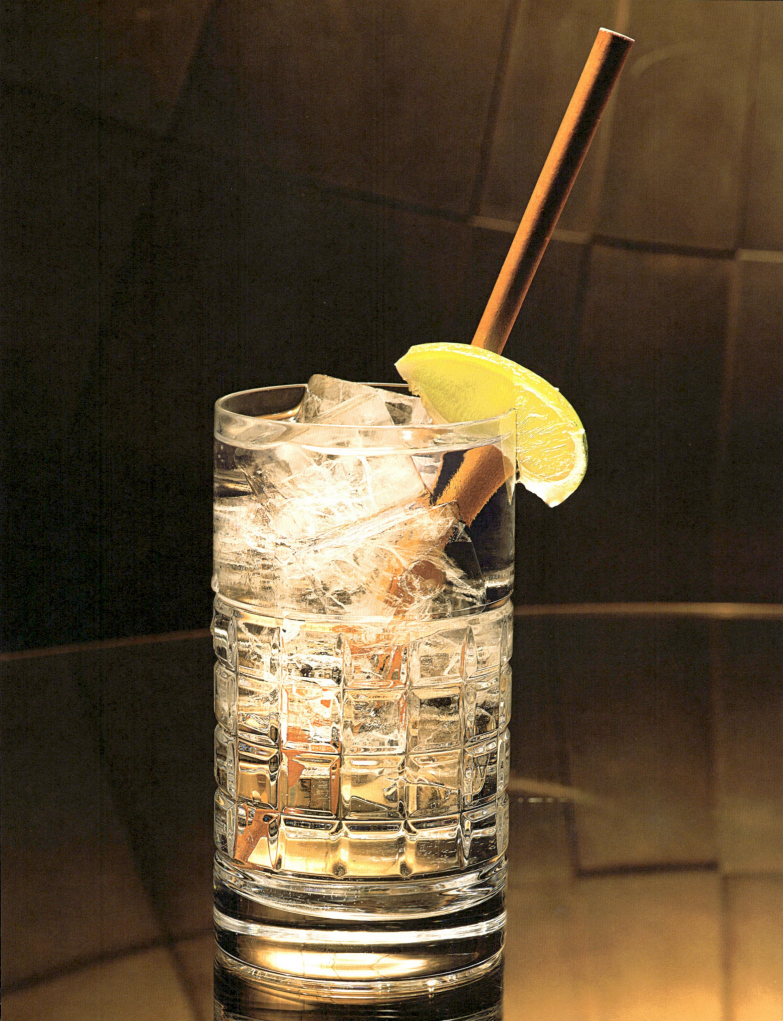

THE CHARLIE CHAPLIN

1 oz. ROTHMAN & WINTER ORCHARD APRICOT BRANDY
(THE ORIGINAL MAY HAVE USED APRICOT EAU-DE-VIE)

1 oz. PLYMOUTH SLOE GIN

1 oz. FRESH SQUEEZED LIME JUICE

GARNISH: LIME PEEL

PLACE ALL INGREDIENTS INTO A MIXING TIN, ADD LARGE ICE, SHAKE VIGOROUSLY, TASTE FOR BALANCE, DOUBLE STRAIN INTO GLASS, GARNISH AND SERVE.

Sir Charles Spencer "Charlie" Chaplin may have never had one himself, but just prior to Prohibition in 1920 the Waldorf Astoria in New York City made famous the Charlie Chaplin Cocktail. The equal mix of lime juice, apricot brandy, and sloe gin is documented in A. S. Crockett's *The Old Waldorf Astoria Bar Book*.

74

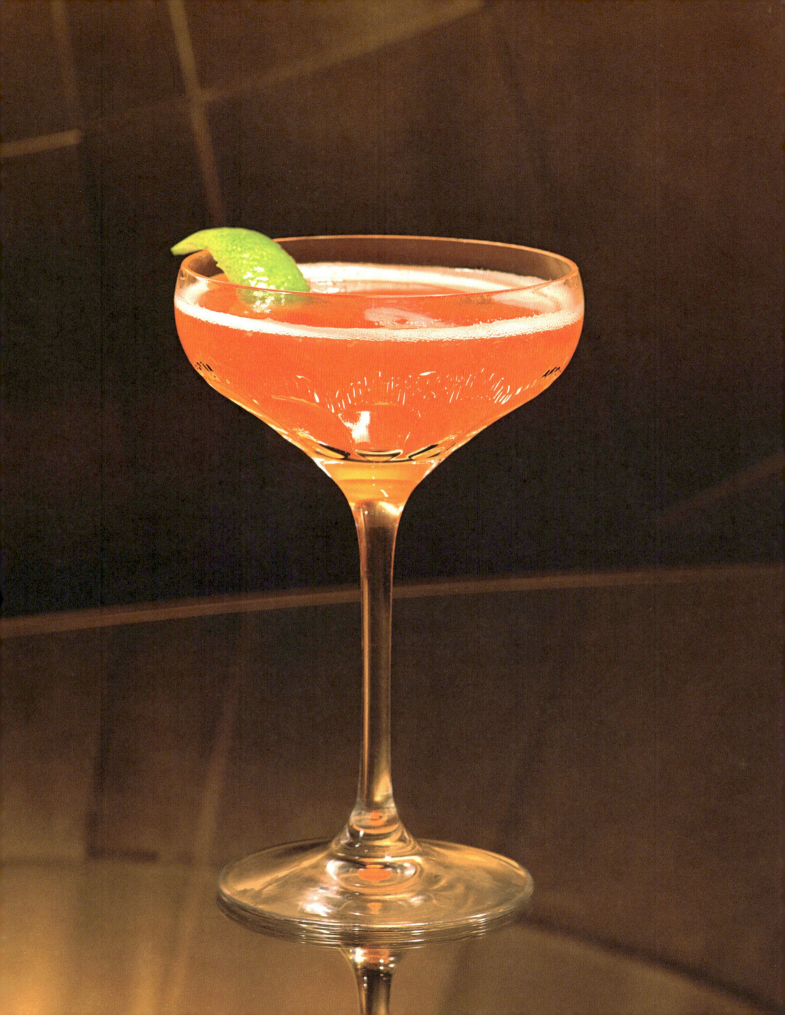

LYNCHBURG LEMONADE

1 oz. JACK DANIEL'S

1/2 oz. COINTREAU

1 1/2 oz. FRESH LEMON JUICE

1 1/2 oz. SIMPLE SYRUP

1/2 oz. CLUB SODA
(OPTIONAL: SPRITE)

GARNISH: LEMON WEDGE

ADD ALL INGREDIENTS TO MIXING TIN (EXCEPT CLUB SODA)
AND SHAKE VIGOROUSLY,
ADD CLUB SODA, TUMBLE
ROLL BACK AND FORTH ONCE,
TASTE FOR BALANCE, DOUBLE STRAIN
OVER FRESH ICE, GARNISH AND SERVE.

Frank Sinatra, or Ol' Blue Eyes, was perhaps
the most-known member of the Rat Pack.
It's common knowledge that Sinatra loved
Jack Daniel's—so much so that he was buried
with a bottle. His ritual of three cubes,
two fingers of Jack, and a splash of water
after every show is well-known. This is what
I would I pour for Sinatra.

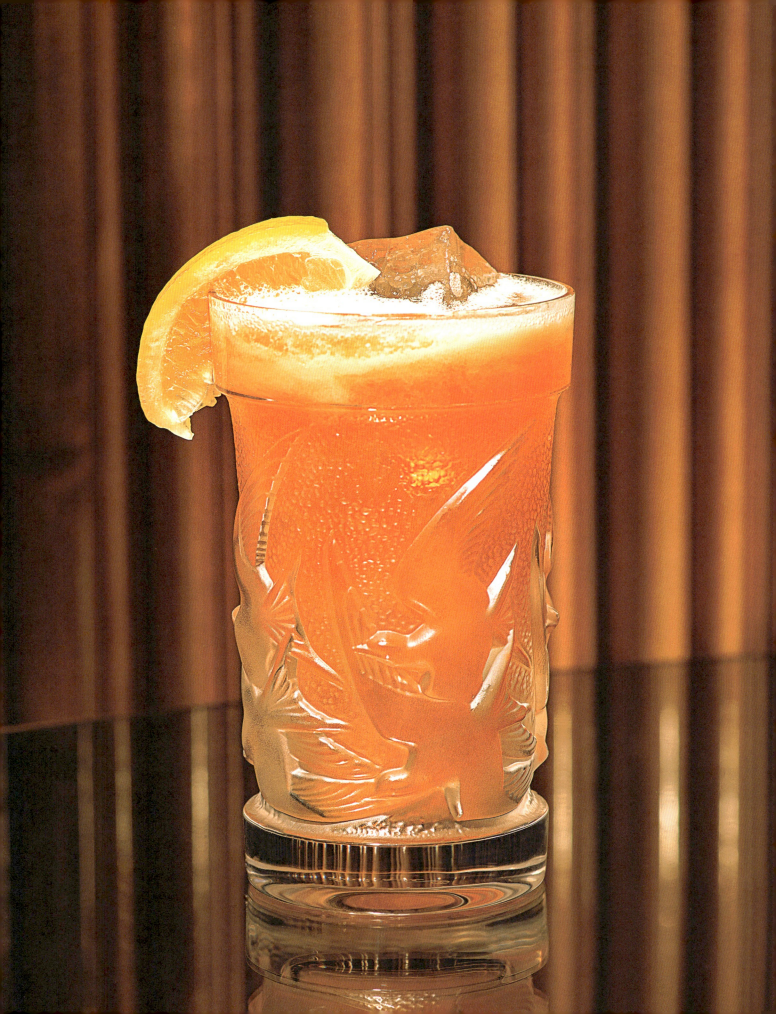

BOBBY BURNS

2 oz. CUTTY SARK PROHIBITION EDITION
1 oz. SWEET VERMOUTH
1/2 oz. BÉNÉDICTINE LIQUEUR

GARNISH: ORANGE TWIST

PLACE ALL INGREDIENTS INTO A MIXING GLASS, ADD LARGE ICE, STIR THOROUGHLY, TASTE FOR BALANCE, STRAIN SLOWLY INTO GLASS, GARNISH AND SERVE.

Greta Garbo was an international star and icon during Hollywood's silent and golden era who retired at thirty-six after making only twenty-six films. She chose to retire in Manhattan, where she felt she could blend in without being recognized. While Garbo enjoyed Stolichnaya Vodka, her spirit of choice was Cutty Sark blended Scotch whiskey.

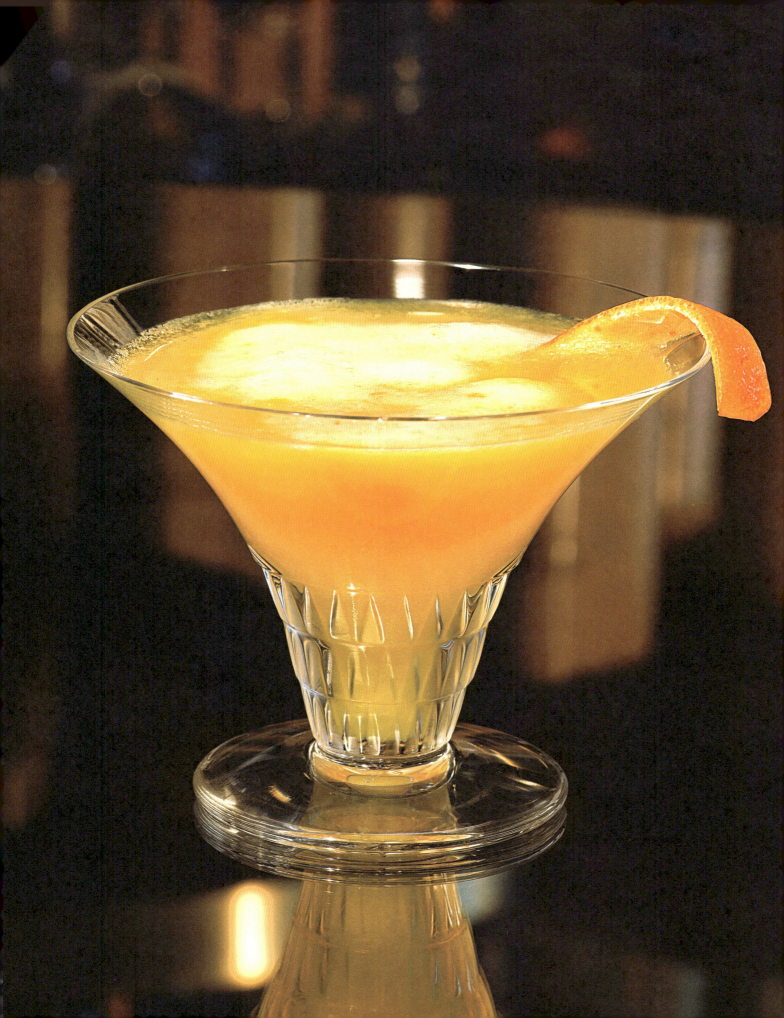

IRISH MANHATTAN

(FIVE POINTS)

might be a Peck's Irish favorite

1 1/2 oz JAMESON'S IRISH WHISKEY

3/4 oz. CARPANO ANTICA FORMULA SWEET VERMOUTH

3 1/4 oz. GUINNESS

2 DASHES OF ANGOSTURA BITTERS

PUT IRISH WHISKEY AND SWEET VERMOUTH IN A MIXING GLASS, POUR GUINNESS FROM A NITROGEN TAP AND "STACK" THE GUINNESS TWICE TO GET A TIGHT FROTHY HEAD, ADD TWO DROPS OF ANGOSTURA BITTERS IN THE CENTER OF THE GLASS, USE COCKTAIL STIRRER TO MAKE A SHAMROCK, SERVE.

In 1969, President Lyndon Johnson
honored Gregory Peck with the Presidential Medal of Freedom
for his lifetime humanitarian efforts, one of which
was being a founding patron of the University
College Dublin School of Film. The most famous Irish stout,
Guinness, also happens to be Peck's favorite drink.
Eventually he had a tap installed in the bar at his house.

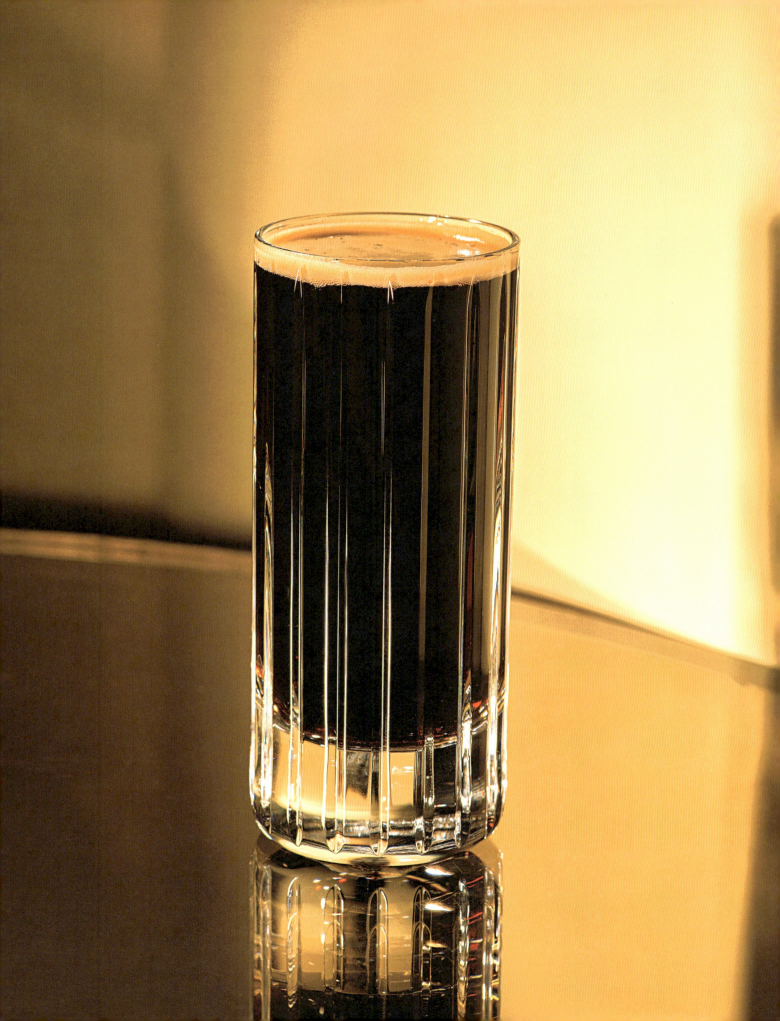

DIRTY MARTINI

2 OZ. ABSOLUT VODKA
1 OZ. OLIVE JUICE

GARNISH: THREE OLIVES

PLACE ALL INGREDIENTS INTO A MIXING TIN, ADD LARGE ICE AND SHAKE VIGOROUSLY, SINGLE STRAIN INTO GLASS, GARNISH AND SERVE IN CHILLED MARTINI GLASS.

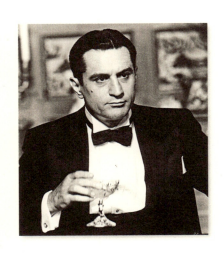

Robert De Niro and his wife Grace Hightower-De Niro would occasionally drop by Per Se restaurant for a quick bite to eat when I was working there from 2004-07. While Mrs. De Niro was partial to Veuve Clicquot Champagne, Mr. De Niro always started with the same Martini: vodka, shaken extra hard, three olives, and a bit of olive brine, single-strained into a chilled martini glass. A proper martini is traditionally not shaken, but at Per Se the guest is always right.

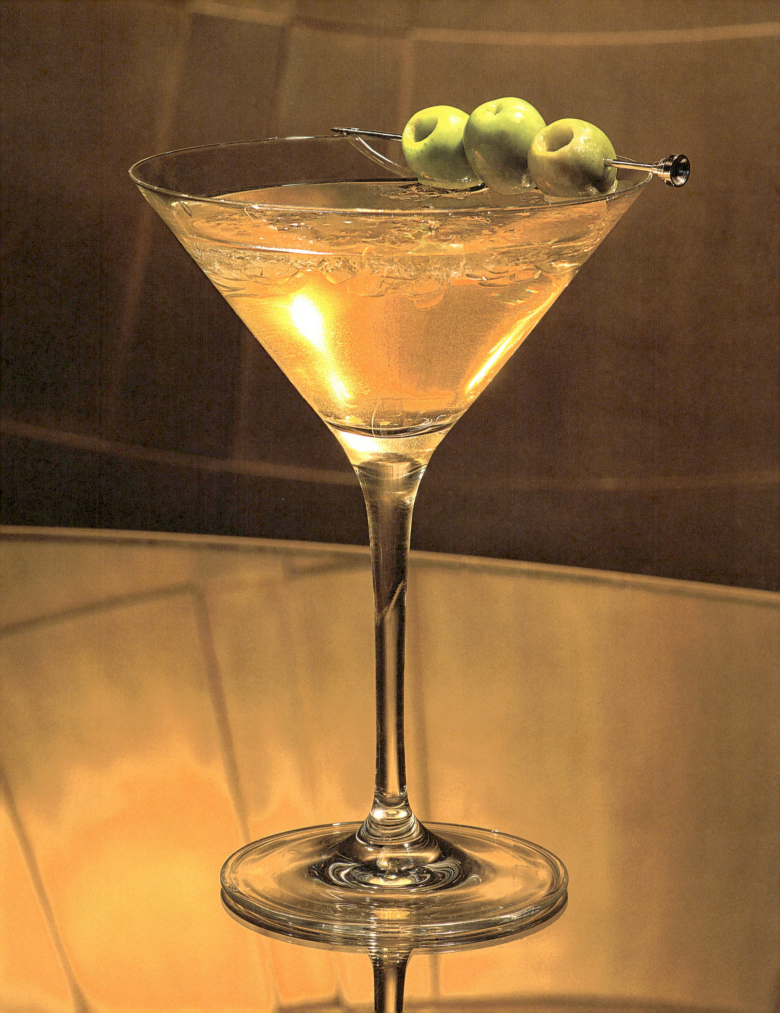

MARGARITA

2 oz. DON JULIO BLANCO TEQUILA

1 oz. COINTREAU TRIPLE SEC

3/4 oz. FRESH LIME JUICE

TOMMY'S MARGARITA

2 oz. DON JULIO REPOSADO TEQUILA

1 oz. AGAVE NECTAR

1 oz. FRESH LIME JUICE

GARNISH: FRESH LIME WEDGE;
OPTIONAL SALT (FOR MARGARITA)

PLACE ALL INGREDIENTS INTO A MIXING TIN, ADD LARGE ICE, SHAKE VIGOROUSLY, DOUBLE STRAIN INTO GLASS OVER FRESH ICE, GARNISH AND SERVE.

There are many legends about who invented the Margarita Cocktail. Many believe that Margarita Sames (Texan socialite) created it in Acapulco in 1948. However, a lesser-known legend is that a bartender in Tijuana created it to impress Rita Hayworth. Either way, it remains the number-one ordered cocktail in North America.

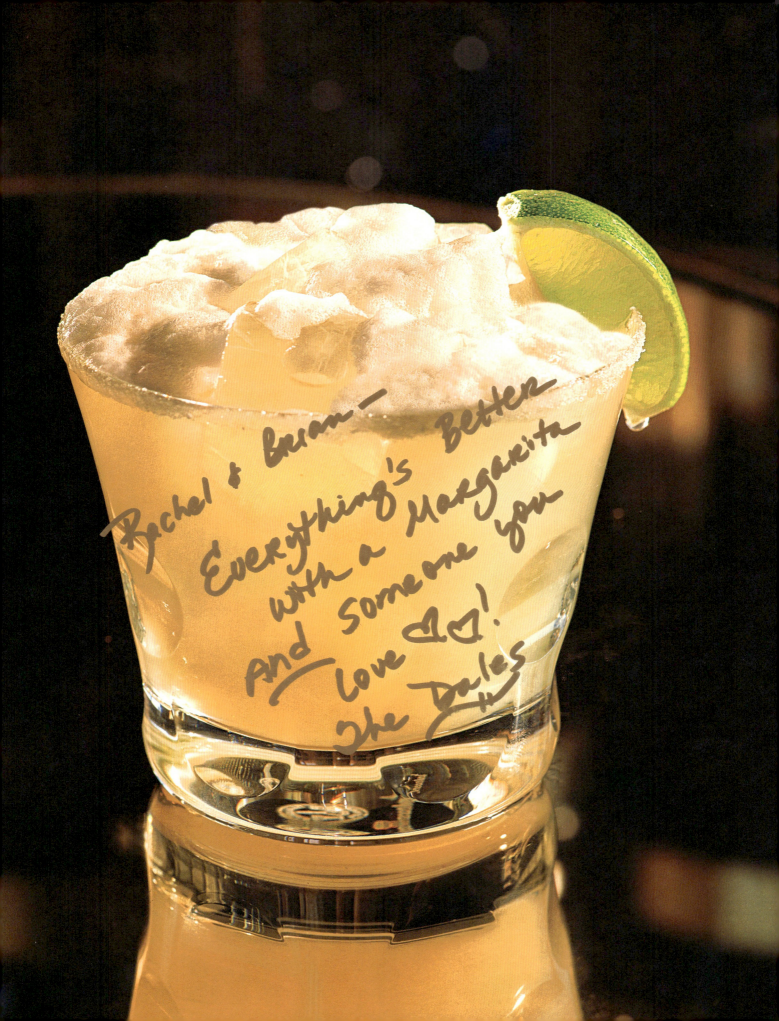

THE LOWER MANHATTAN

2 oz. KILBEGGAN IRISH WHISKEY

1 oz. CARPANO ANTICA FORMULA SWEET VERMOUTH

2 DASHES ANGOSTURA ORANGE BITTERS

GARNISH: ORANGE PEEL TWIST

PLACE ALL INGREDIENTS INTO A MIXING GLASS, ADD LARGE ICE, STIR THOROUGHLY, TASTE FOR BALANCE, SLOWLY POUR INTO GLASS, GARNISH AND SERVE.

Prior to becoming Hollywood royalty, James Cagney came from humble beginnings in New York City. His first job was as a bartender on the Lower East Side during Prohibition when it was illegal to serve alcohol. Cagney's own drink of choice was Irish whiskey (with a high rye content). He once quipped: "Lots of people like to drink to get drunk. I drink to celebrate and I like to celebrate all day and into the night...if I can make it that far."

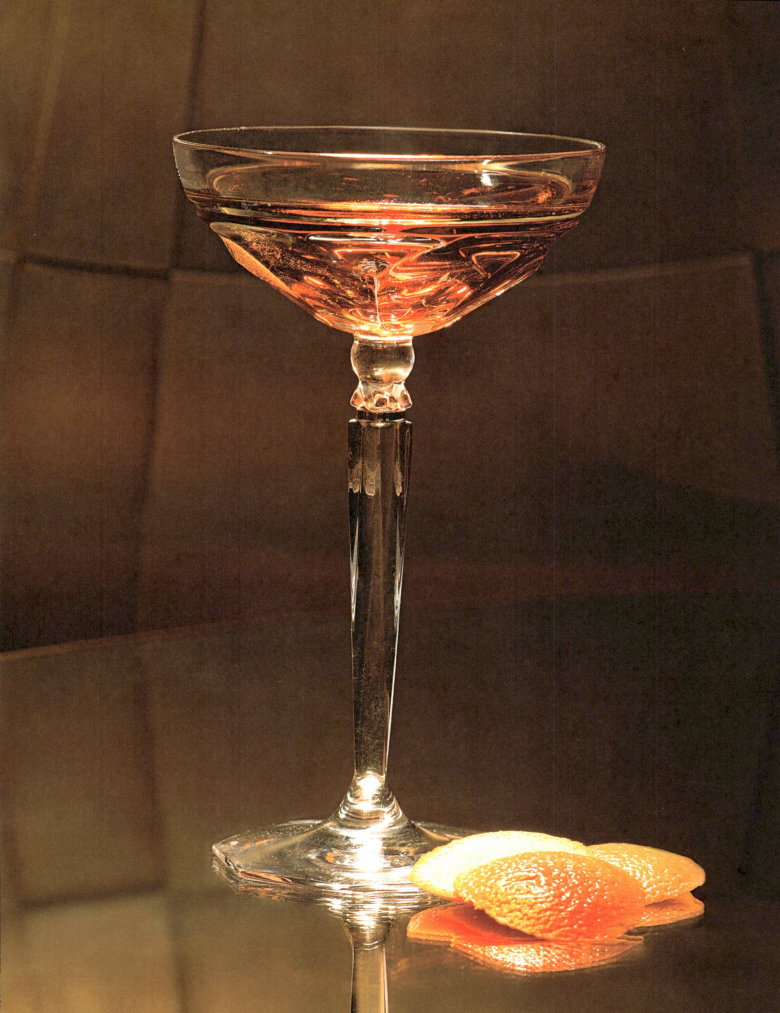

"Drinking is a way of ending the day."

Ernest Hemingway

THE ORIGINAL SAZERAC

1 SUGAR CUBE
2 DASHES PEYCHAUD'S BITTERS
2 oz. FORGE ET FILS COGNAC
2 DASHES OF ABSINTHE (RINSE)

GARNISH : LEMON PEEL TWIST

RINSE OUT THE GLASS WITH ABSINTHE, SOAK SUGAR CUBE WITH BITTERS AND PLACE IN A MIXING GLASS WITH COGNAC, MUDDLE SUGAR CUBE UNTIL DISSOLVED, ADD LARGE ICE, STIR THOROUGHLY, TASTE FOR BALANCE, SLOWLY POUR INTO GLASS OVER ONE LARGE ICE CUBE OR SPHERE.

The Sazerac is a local New Orleans variation of a classic Cognac or rye Old-Fashioned cocktail. In the film *The Curious Case of Benjamin Button* (2008), Benjamin's father orders two Sazeracs for him and his son (played by Brad Pitt) at a brothel in New Orleans. As of 2008 the Sazerac was named the official cocktail of New Orleans.

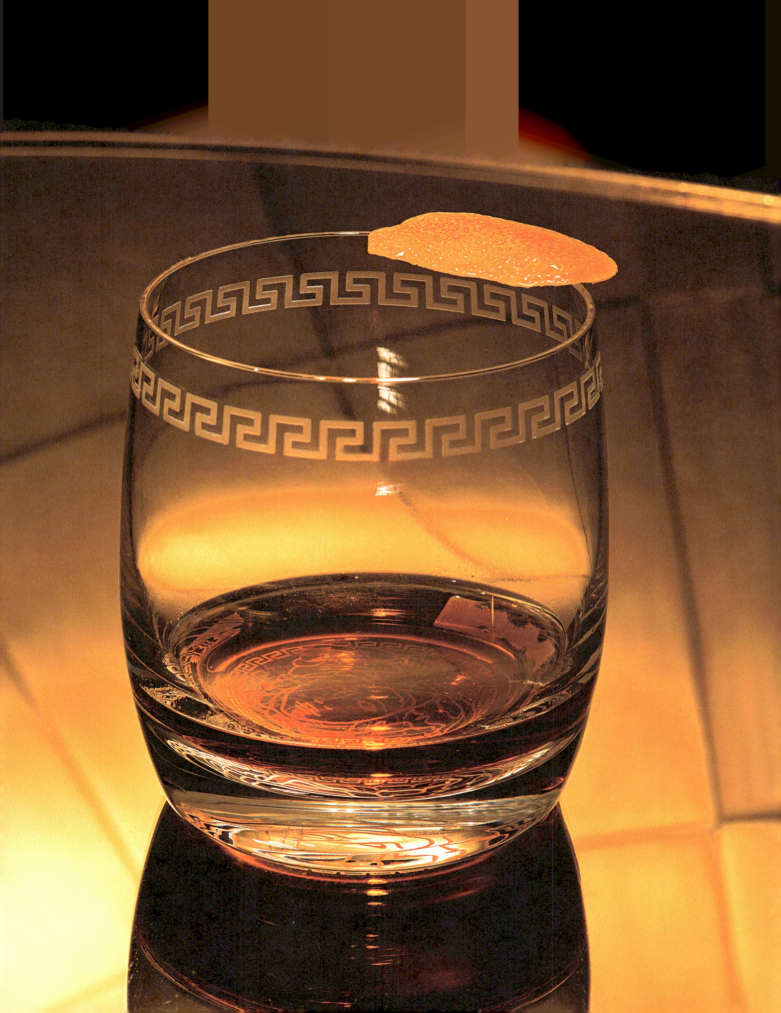

CHAMPAGNE COCKTAIL

GARNISH: LEMON SPIRAL TWIST

CHAMPAGNE
1 SUGAR CUBE
SOAKED IN
ANGOSTURA
BITTERS

SOAK SUGAR CUBE IN BITTERS AND DROP INTO BOTTOM OF GLASS. VERY SLOWLY ADD CHAMPAGNE TO WITHIN A HALF-INCH OF THE TOP OF GLASS. ADD LEMON SPIRAL TWIST.

Bette Davis once said, "There comes a time in every woman's life when the only thing that helps is a glass of champagne." Davis liked to drink bourbon later in life, and consented to a national ad campaign with a very young Robert Wagner in 1972 to promote Jim Beam Bourbon. Try adding a half-ounce of bourbon to the recipe above.

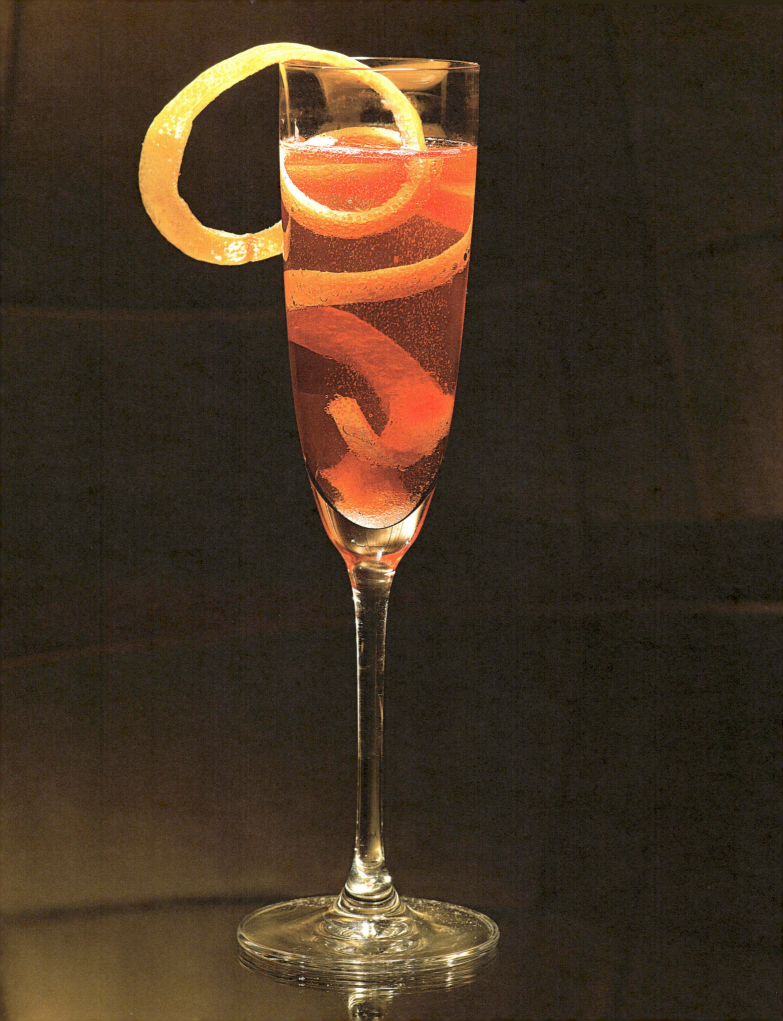

TAYLORED
BLACK RUSSIAN

1 oz. ABSOLUT VODKA
1 oz. KAHLUA
1 oz. HERSHEY'S CHOCOLATE SYRUP

HEAT CHOCOLATE SYRUP TILL WARM,
POUR ALL INGREDIENTS INTO A MIXING GLASS
AND STIR UNTIL THOROUGHLY MIXED,
ADD LARGE ICE AND STIR AGAIN UNTIL PROPERLY
CHILLED, TASTE FOR BALANCE, SLOWLY POUR
FRESH ICE AND SERVE.

Liz Taylor's daily diet reportedly consisted
of the following: scrambled eggs, bacon,
and a mimosa for breakfast; French bread filled
with peanut butter and bacon for lunch; and fried
chicken, peas, biscuits, gravy, mashed potatoes,
corn bread, homemade potato chips, trifle,
and a tumbler full of Jack Daniel's for dinner.
She once said her favorite cocktail was Hershey's
Syrup, vodka, and Kahlua.

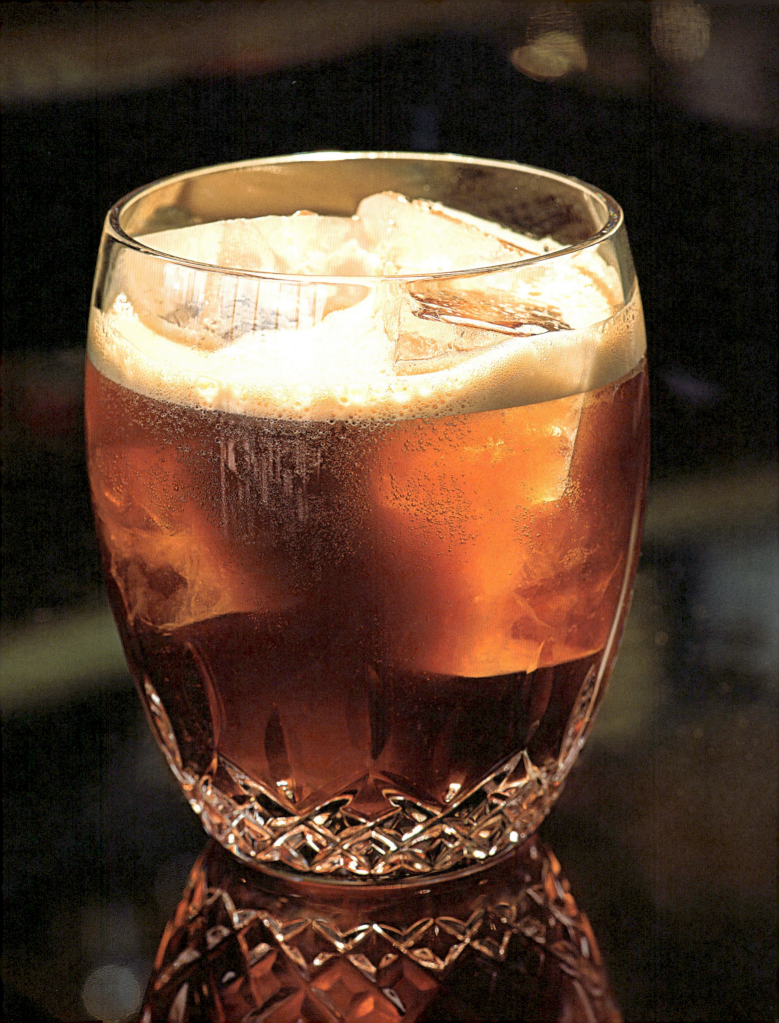

HOUSE OF FRIENDS

1 1/2 oz. CASAMIGOS BLANCO TEQUILA
1/4 oz. CHARTREUSE (YELLOW)
1/4 oz. COINTREAU
1 oz. AGAVE NECTAR
1 oz. FRESH SQUEEZED LIME JUICE

GARNISH - FRESH GRATED
NUTMEG

PLACE ALL INGREDIENTS INTO A MIXING TIN, ADD LARGE ICE, SHAKE VIGOROUSLY, TASTE FOR BALANCE, DOUBLE STRAIN INTO GLASS, GARNISH AND SERVE.

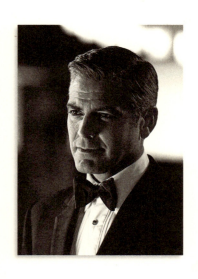

George Clooney teamed up with next-door neighbor Rande Gerber in Los Cabos, Mexico, to create "the highest quality tequila the world has ever seen." The result was an award-winning 100% agave tequila produced in the highlands of Jalisco, Mexico—Casamigos. I created this tribute cocktail to honor the friendship, and while the ingredients sound unusual, they come together like old friends who, when they meet, always have a good time.

Mr. + Mrs. Winn!
Congratulations on
your beautiful marriage.
I cannot wait to see what
this life has in store for you.
love,
Lauren Brinker

Congrats! We
love you two!
So happy for
y'all!
Cassie + Greg

BLACK EMERALD

1 1/2 oz. SMIRNOFF VODKA
1 BLACK TEA BAG
1 oz. St-GERMAIN ELDERFLOWER LIQUEUR
1/2 oz. LEMON JUICE
2 oz. CLUB SODA
2 LARGE MINT LEAVES

GARNISH: 1 LARGE MINT LEAF AND LEMON WEDGE.

STEEP TEA BAG IN CLUB SODA FOR AT LEAST THREE MINUTES, ADD ALL OTHER INGREDIENTS IN A MIXING TIN, ADD LARGE ICE AND SHAKE VIGOROUSLY. ADD CLUB SODA, TUMBLE ROLL BACK AND FORTH ONCE, TASTE FOR BALANCE, DOUBLE STRAIN OVER FRESH ICE, GARNISH AND SERVE.

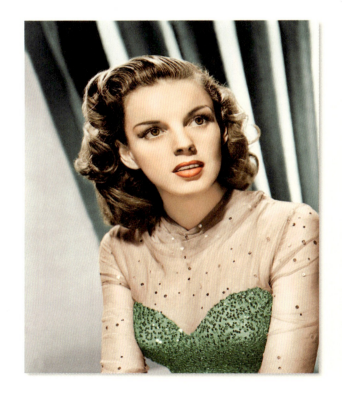

During the filming of *The Wizard of Oz* (1939), Judy Garland kept laughing during the scene where she had to slap the Cowardly Lion, so director Victor Fleming pulled her aside and slapped her across the face—she came back red-faced and nailed the scene. Garland's favorite cocktail was black tea and vodka.

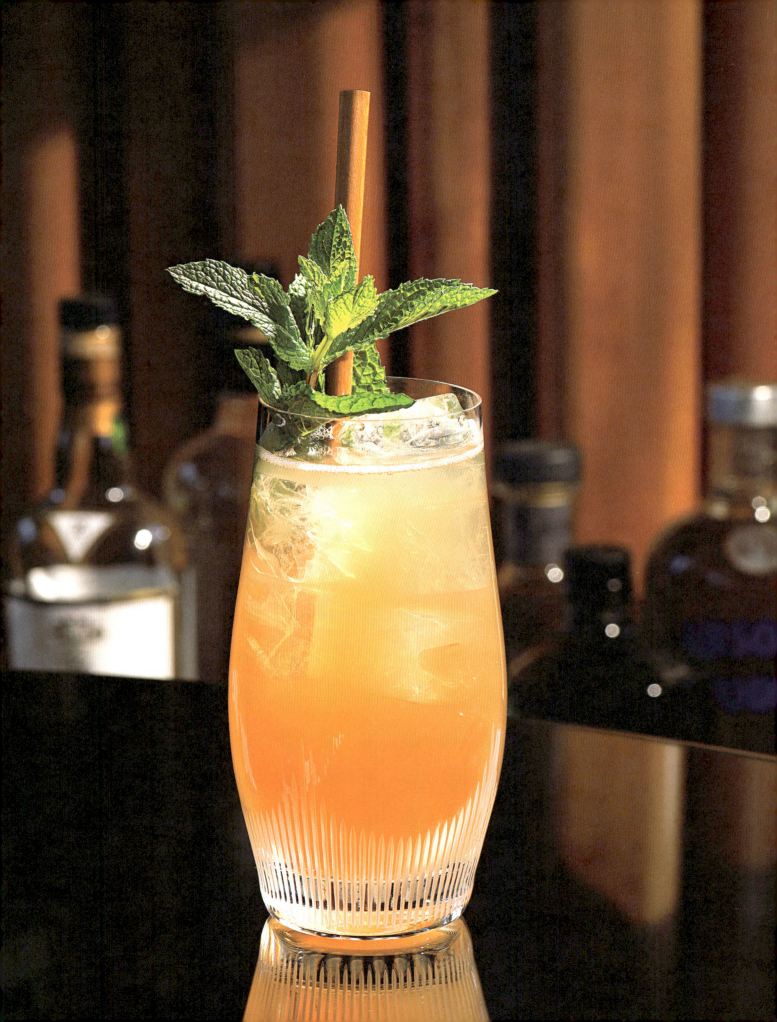

ROYALE MARTINI

1 1/2 oz. KETEL ONE **VODKA**

1/2 oz. CRÈME DE CASSIS

2 oz. PERRIER-JOUËT BRUT **CHAMPAGNE**

GARNISH : LEMON ZEST TWIST

ADD VODKA AND CASSIS TO A MIXING GLASS, LARGE ICE, STIR THOROUGHLY, CHAMPAGNE AND SLOWLY POUR INTO GLASS, GARNISH AND SERVE.

Not to be confused with Martini Royale, the Royale Martini cocktail is essentially a Kir Royale made with vodka. Every year countless celebrities travel from Hollywood to attend the Cannes Film Festival. While the Kir Royale is consumed up and down the French Riviera, traveling celebrities who wanted something with a little more kick made the Royale Martini popular in Cannes.

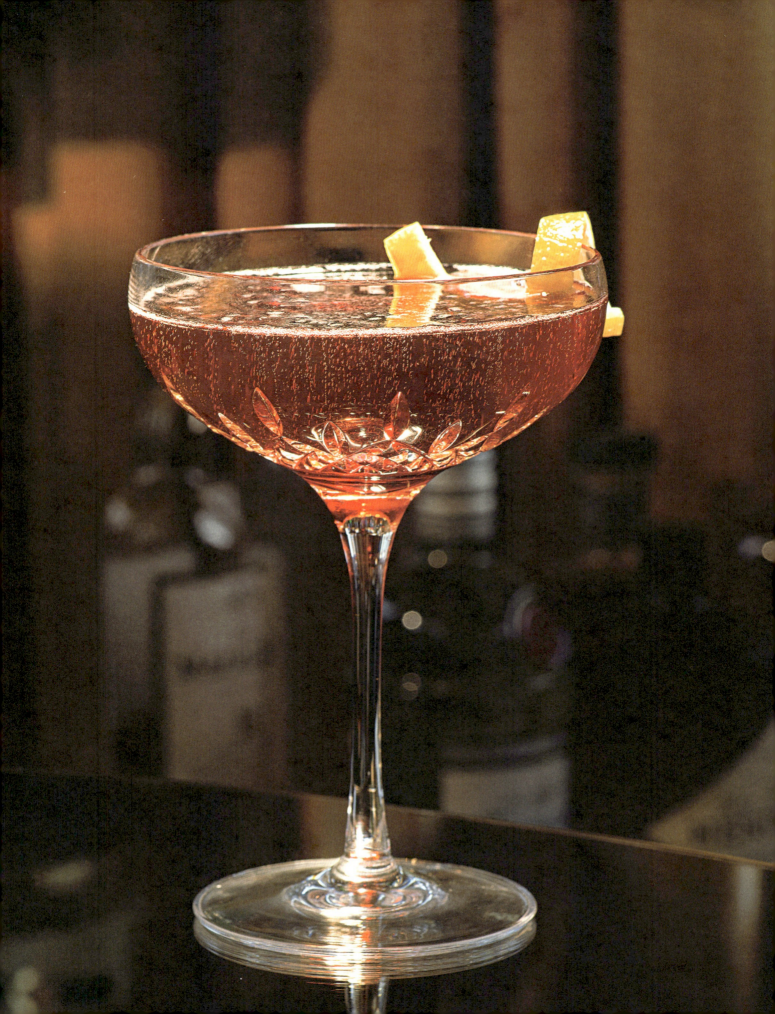

SCOTCH & SODA

3 oz. KING WILLIAM IV SCOTCH

1 oz. SODA WATER

GARNISH: OPTIONAL LEMON WEDGE

PLACE LARGE ICE INTO HIGHBALL GLASS, ADD SCOTCH AND SODA WATER, TUMBLE ROLL BACK AND FORTH ONE TIME, GARNISH AND SERVE.

With her unconventional lifestyle and the independent characters she played, Katherine Hepburn came to epitomize the "modern woman" of her day and refused to conform to society's expectations. Though it was traditionally considered "a man's drink," Hepburn enjoyed drinking rye whiskey or a strong Scotch & Soda with friends.

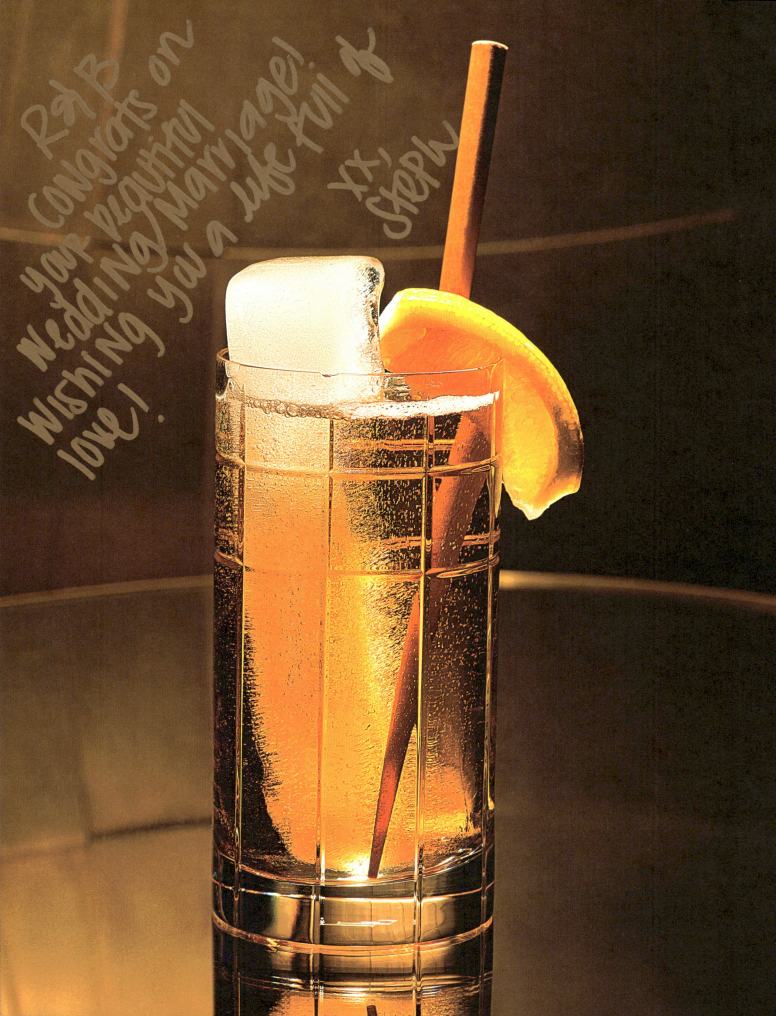

R & B
Congrats on
your beautiful
wedding! Marriage!
Wishing you a life full of
love!
xx,
Steph

COFFEE COCKTAIL

(FROM PROFESSOR JERRY THOMAS 1887)

1 oz. COURVOISIER V.S.O.P. COGNAC
1 oz. TAYLOR FLADGATE RUBY PORT
1 WHOLE EGG
1/2 oz. SIMPLE SYRUP

GARNISH: FRESH GROUND NUTMEG

PLACE ALL INGREDIENTS IN A MIXING GLASS, ADD LARGE ICE, SHAKE VIGOROUSLY, STRAIN INTO GLASS, GARNISH AND SERVE.

James Dean's stardom is based solely on his only three films:
Rebel Without a Cause (1955), *East of Eden* (1955), and *Giant* (1956).
Dean's first public performance was for the Women's Christian Temperance Union,
where he demonstrated the evils of alcohol by portraying the ruined life
of a drunk. James was once asked what his favorite drink was.
His answer: Coffee! Java lovers will love the classic Coffee Cocktail
even though it has absolutely no coffee in it.

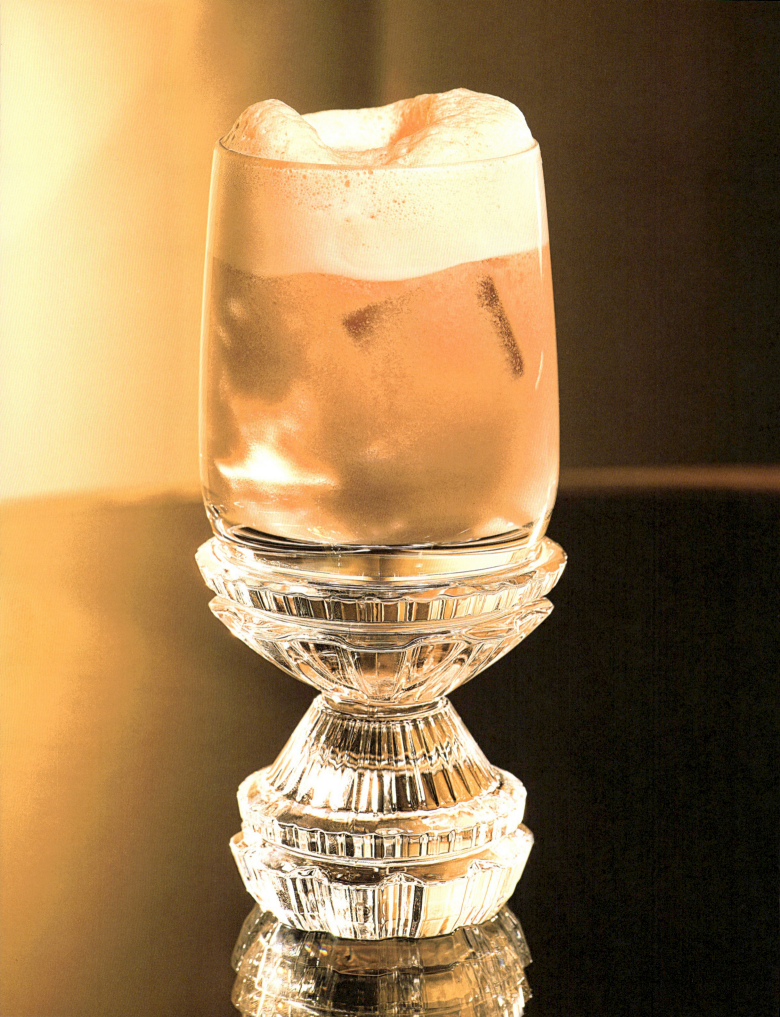

TEQUILA
MANHATTAN

1 1/2 oz. DON JULIO 1942

1/2 oz. DOLIN SWEET VERMOUTH

2 DASHES ANGOSTURA ORANGE BITTERS

GARNISH: ORANGE SPIRAL TWIST

PLACE ALL INGREDIENTS INTO A MIXING GLASS, ADD LARGE ICE, STIR THOROUGHLY, TASTE FOR BALANCE, GARNISH AND SERVE.

Kurt Russell was cast in several films by director John Carpenter, including *Escape from New York* (1981) and the kung fu comedy/action film *Big Trouble in Little China* (1986), all of which have since become cult classics. This cocktail, made with 100% agave añejo tequila, is a tribute to Mr. Russell's roles.

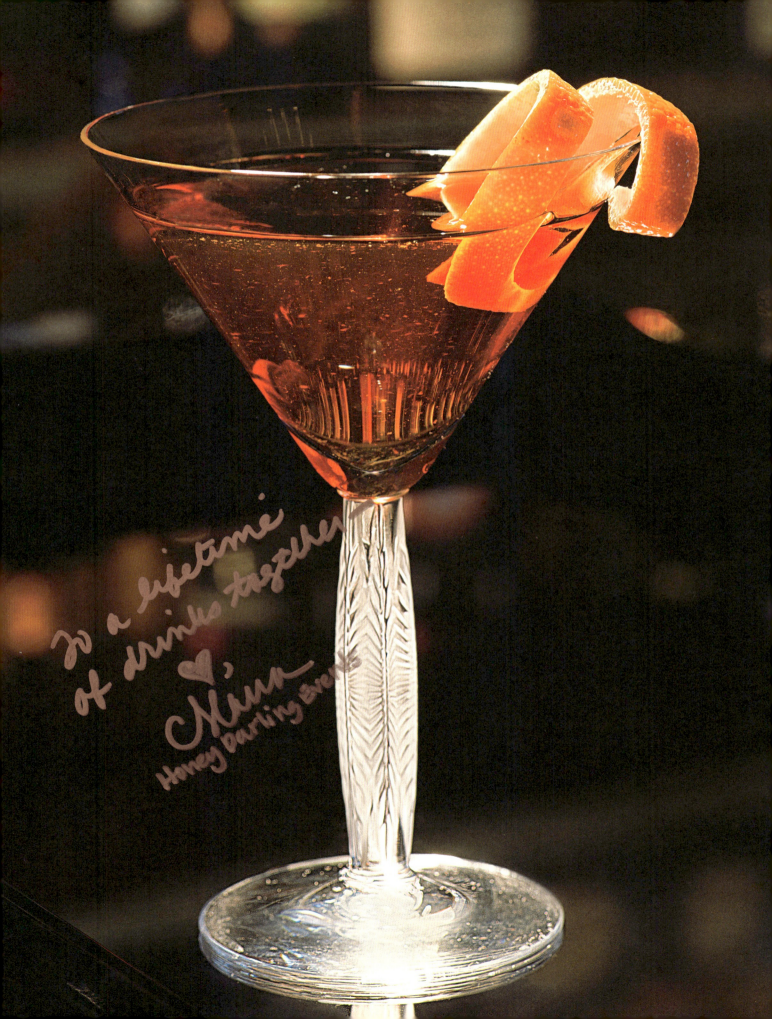

To a lifetime
of drinks together
♡,
Mina
Honey Darling Events

" Alcohol may be man's worst enemy, but the Bible says love your enemy. "

Frank Sinatra

Sean Connery in *Goldfinger*, 1964.

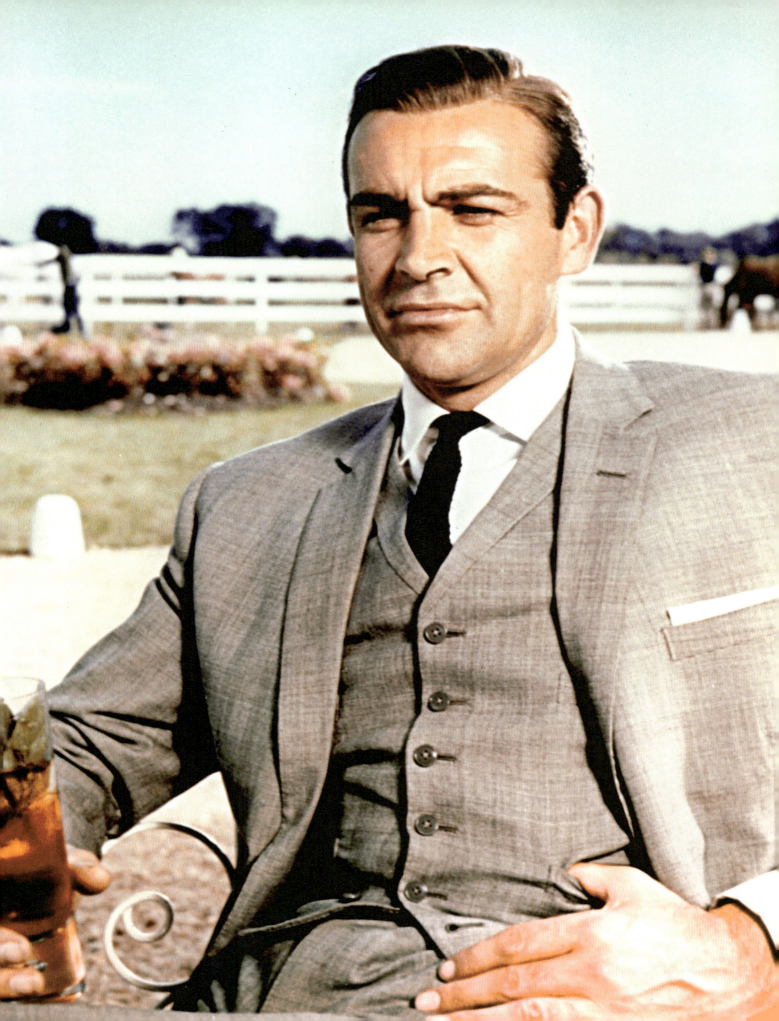

NEGRONI

1 oz. TANQUERAY TEN GIN

1 oz. CARPANO ANTICA FORMULA SWEET VERMOUTH

1 oz. CAMPARI GARNISH: ORANGE PEEL TWIST

PLACE ALL INGREDIENTS IN A MIXING GLASS, ADD LARGE ICE, STIR THOROUGHLY, TASTE FOR BALANCE, SLOWLY POUR OVER FRESH ICE CUBES AND TWIST OILS FROM ORANGE PEELS INTO COCKTAIL. FINALLY, RIM THE GLASS WITH TWIST FOR AROMATICS.

Known as a heavy drinker, Orson Welles loved to drink Scotch whiskey, although he was largely responsible for the popularity of the Negroni cocktail in the United States. While working in Rome on *Cagliostro* (1949), he championed the classic drink by saying, "The bitters are excellent for your liver; the gin is bad for you. They balance each other."

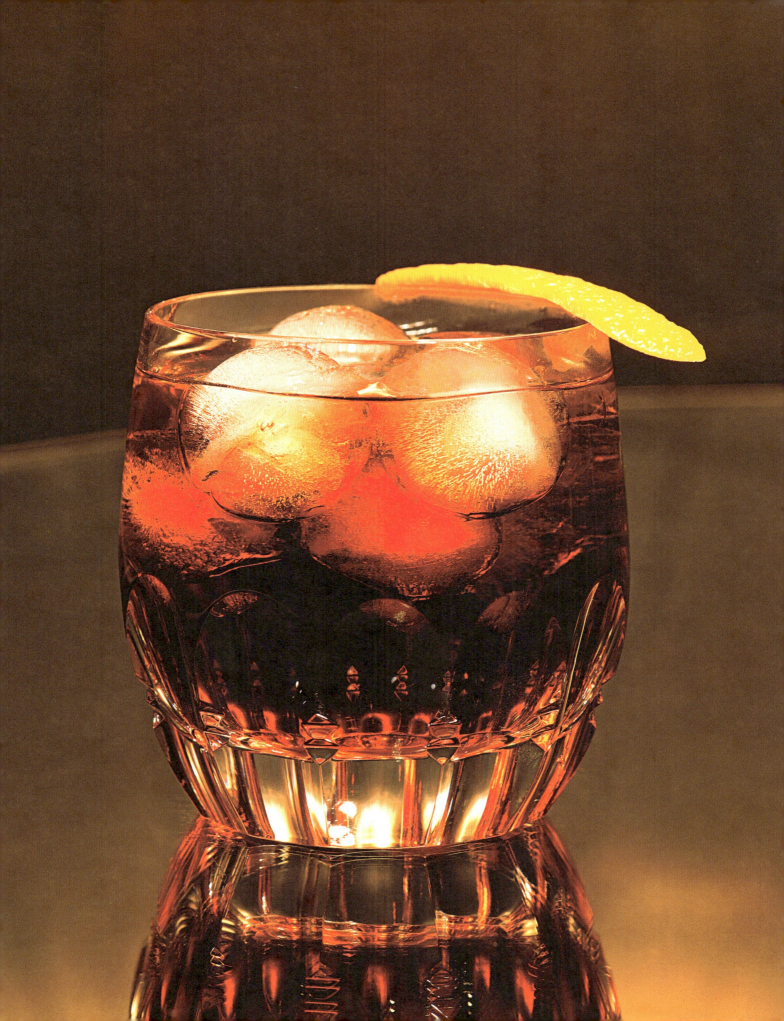

SPRING THAW

1 oz. BARSOL PISCO MOSTO VERDE

1/4 oz. PAUL GIRAUD V.S.O.P. COGNAC

1 oz. FRESH LIME JUICE

1 1/4 oz. SIMPLE SYRUP

1/2 oz. MOSCATO D'ASTI

GARNISH: SLICE OF STARFRUIT

PLACE ALL INGREDIENTS (EXEPT MOSCATO)
INTO A MIXING GLASS, ADD LARGE
ICE AND SHAKE VIGOROUSLY, ADD MOSCATO D'ASTI,
TUMBLE ROLL BACK AND FORTH ONCE,
TASTE FOR BALANCE,
GARNISH AND SERVE.

Peter O'Toole once stated that the actress he most enjoyed
working with was Katherine Hepburn in *The Lion in Winter* (1968),
in which he played Henry II to her Eleanor of Aquitaine
—their drink of choice was Brandywine, which means burnt wine,
or Cognac. This Cognac-based cocktail is a modern classic
named in honor of Mr. O'Toole.

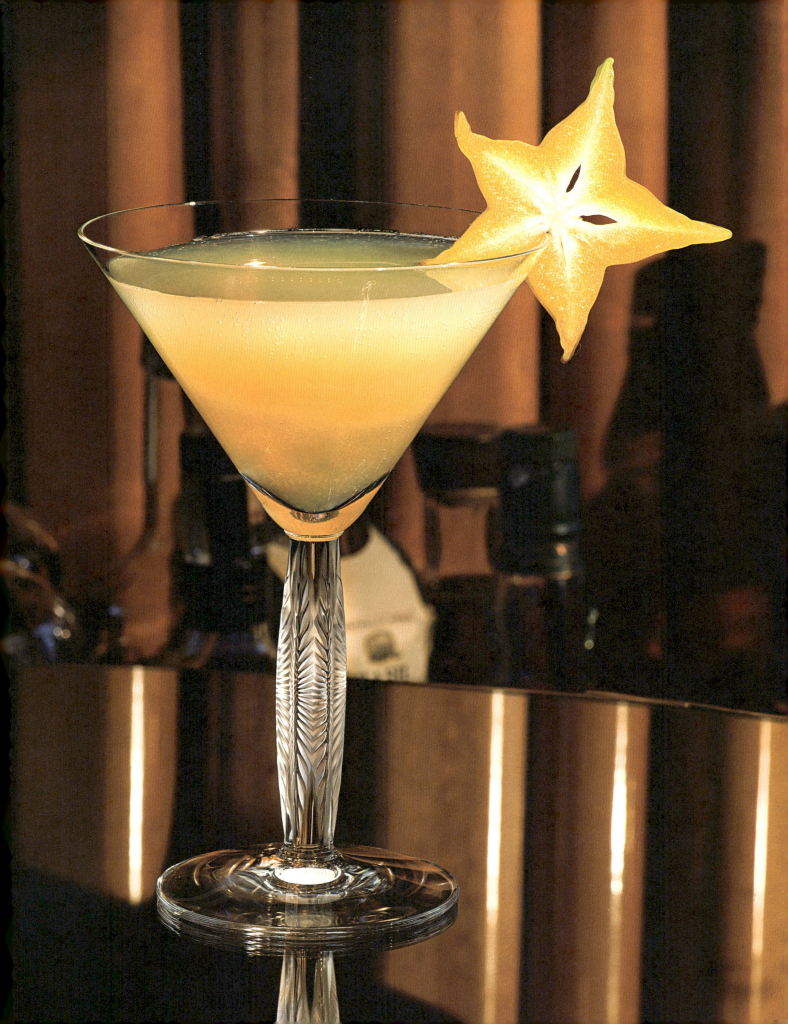

WHISKEY DAISY

1 LIME WEGDE
1/2 LEMON, QUARTERED
3/4 OZ. SIMPLE SYRUP
1/2 OZ. YELLOW CHARTREUSE
1 1/2 OZ. JIM BEAM BOURBON

GARNISH: LEMON WEDGE, BRANDY-SOAKED CHERRY

MUDDLE THE FIRST FOUR INGREDIENTS IN A MIXING GLASS, ADD WHISKEY AND LARGE ICE, SHAKE VIGOROUSLY, DOUBLE STRAIN INTO A TUMBLER FILLED WITH CRUSHED ICE, GARNISH AND SERVE.

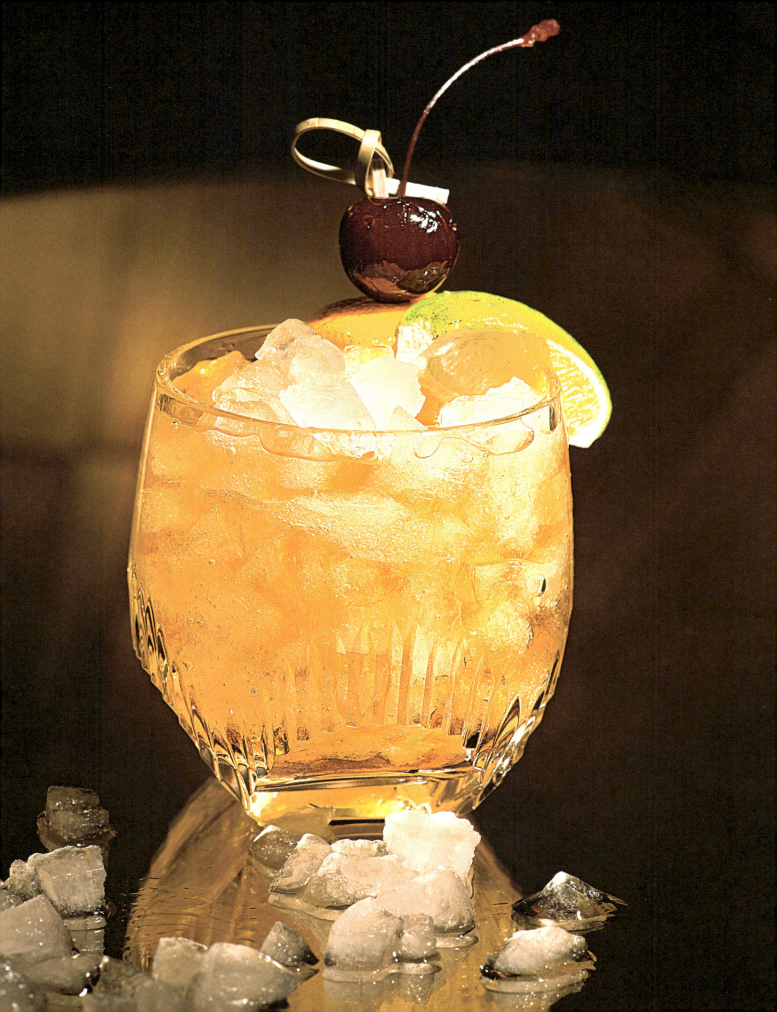

PERFECT STORM

1 oz. GOSLING'S GOLD RUM
1/2 oz. FRESH SQUEEZED LIME JUICE
1 oz. SIMPLE SYRUP
2 oz. GOSLING'S GINGER BEER
1/2 oz. GOSLING'S BLACK SEAL RUM

GARNISH:
LIME WEDGE

PLACE ALL INGREDIENTS INTO A MIXING TIN (EXEPT GINGER BEER AND BLACK RUM). ADD LARGE ICE, SHAKE VIGOROUSLY, ADD GINGER BEER AND TUMBLE ROLL BACK AND FORTH ONCE. TASTE FOR BALANCE AND STRAIN OVER FRESH ICE, FLOAT A LAYER OF BLACK RUM OVER TOP, GARNISH AND SERVE.

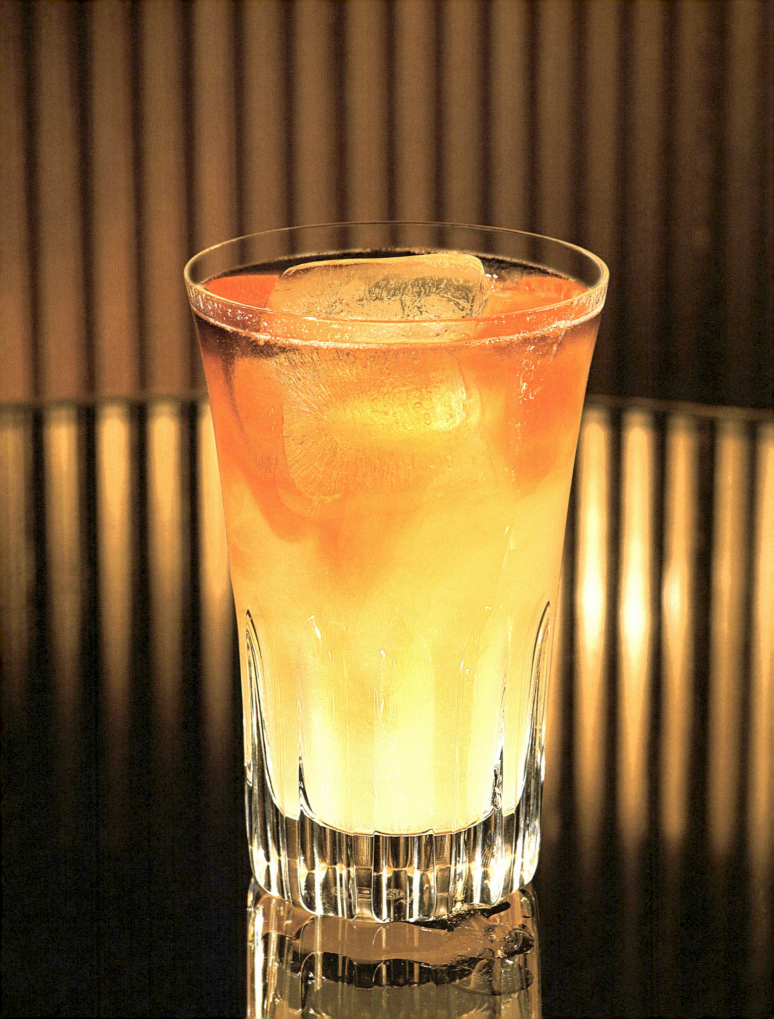

ROB ROY

1 1/2 oz. GLENLIVET ARCHIVE 18 Yr. SINGLE MALT SCOTCH

3/4 oz. DOLIN SWEET VERMOUTH

2 DASHES OF ANGOSTURA BITTERS GARNISH: LEMON TWIST

PLACE ALL INGREDIENTS INTO A MIXING GLASS, ADD LARGE ICE AND STIR THOROUGHLY. TASTE FOR BALANCE, SLOWLY STRAIN INTO COUPE, GARNISH AND SERVE.

The Rob Roy is a classic cocktail created in 1894 at the Waldorf Astoria in New York. The drink was named in honor of the premiere of the operetta *Rob Roy*, loosely based on the Scottish folk hero Robert Roy MacGregor, an eighteenth-century historical figure who battled with feudal landowners in the Scottish Highlands. Liam Neeson played the legendary Scotsman in the 1995 film.

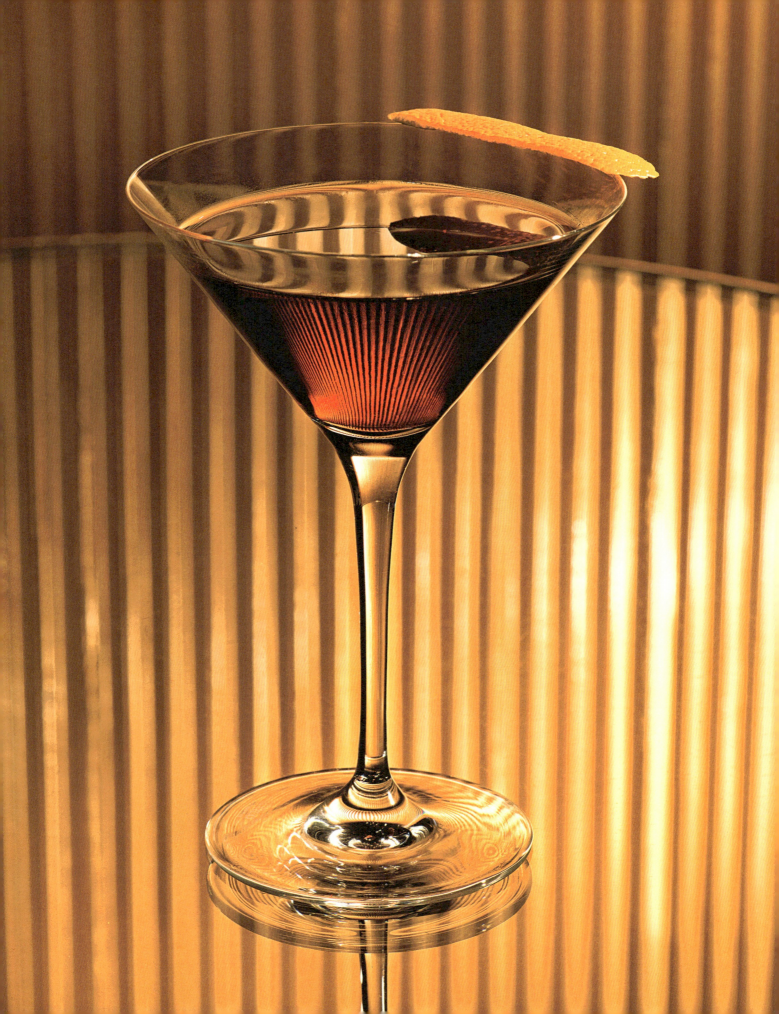

CÎROC DIDDY

1 1/2 oz. CÎROC VODKA
1 oz. FRESH LEMON JUICE
1 1/2 oz. SIMPLE SYRUP
1 oz. CLUB SODA

GARNISH: LEMON WEDGE

PLACE ALL INGREDIENTS INTO A HIGHBALL (EXCEPT CLUB SODA), ADD LARGE ICE AND CLUB SODA.

TUMBLE ROLL BACK AND FORTH ONCE, GARNISH AND SERVE.

In 2009, Sean Combs teamed up with spirits giant Diageo to promote his favorite vodka, Cîroc, a French distillate made from snap frost *Ugni Blanc* grapes (the same grapes used to make Cognac). Master distiller Jean-Sebastian Robicquet created this world-class spirit in an Armagnac-style copper pot still.

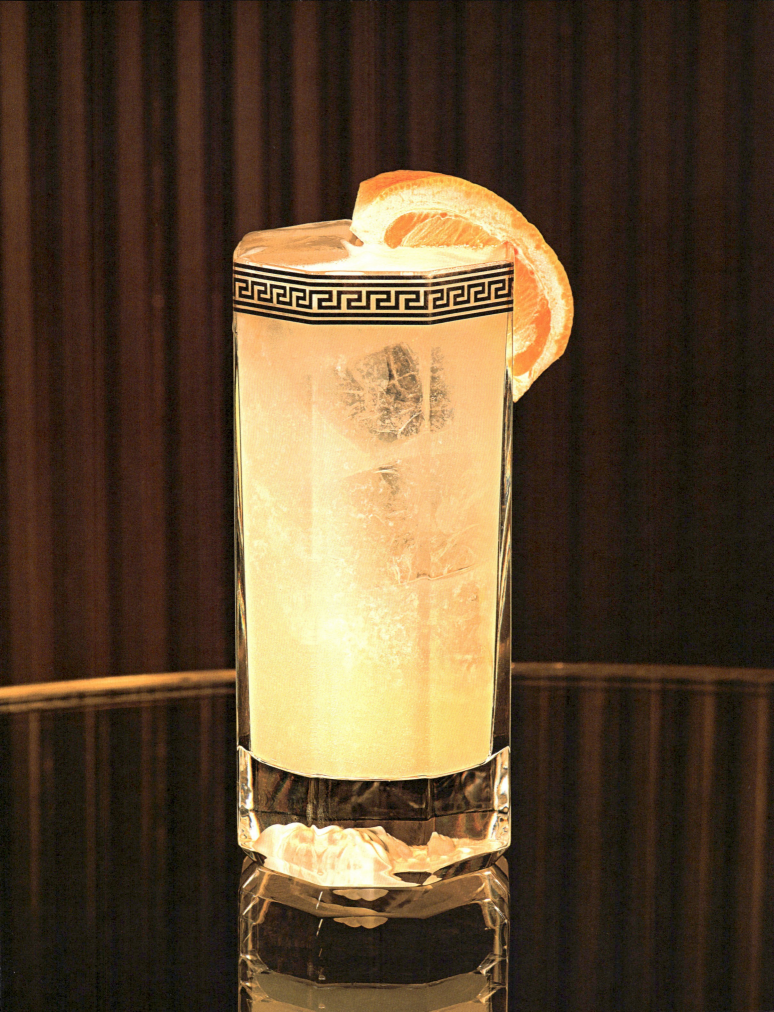

THE DOROTHY

2 oz. BANKS LIGHT RUM (MODERN OPTION: SUBSTITUTE RUM FOR DOROTHY PARKER GIN)

1/2 oz. FRESH ORANGE JUICE

1/2 oz. FRESH PINEAPPLE JUICE

1/4 oz. ROTHMAN & WINTER ORCHARD APRICOT LIQUEUR

GARNISH: ORANGE TWIST

PLACE ALL INGREDIENTS INTO A MIXING TIN, ADD LARGE ICE, SHAKE VIGOROUSLY, TASTE FOR BALANCE, DOUBLE STRAIN INTO GLASS, GARNISH AND SERVE.

Dorothy Parker was a renowned socialite and writer who loved a good cocktail, especially a classic Gin Martini; she once quipped, "I love a good Martini, two at the most—three I'm under the table, and four I'm under the host!"

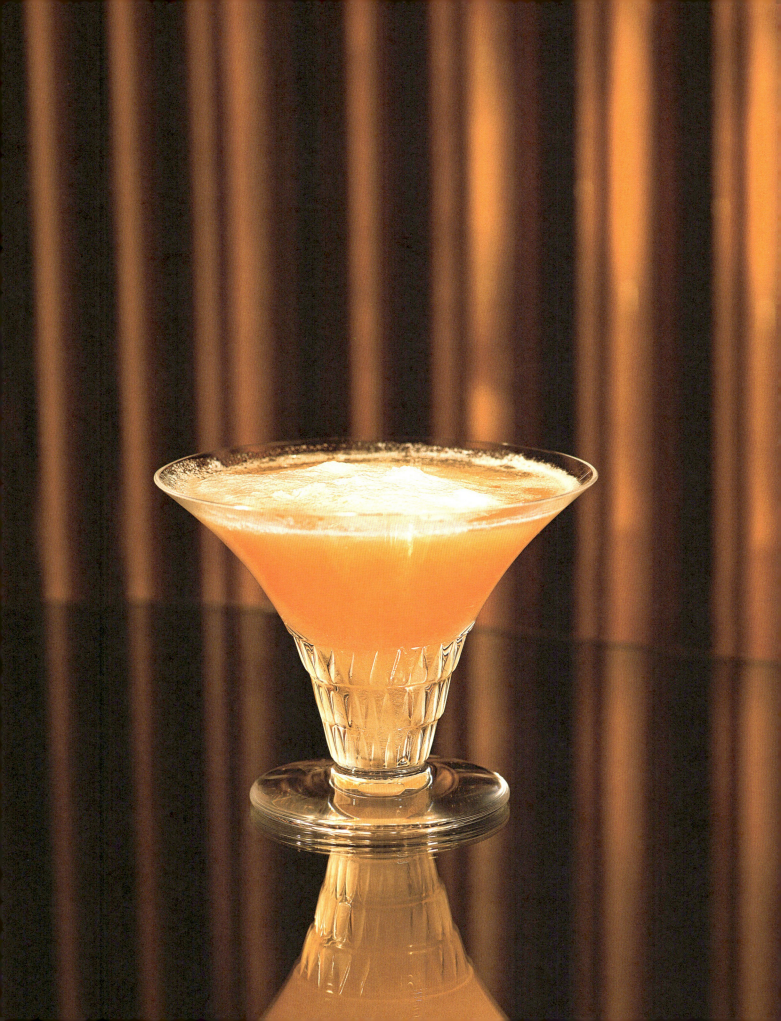

FLAPPER COCKTAIL

1 1/2 oz. THE REAL TIC COY 3Yr. RUM

1 1/2 oz. MARTINI BIANCO (DRY)

1 DASH ANGOSTURA BITTERS

GARNISH : GRAPEFRUIT PEEL TWIST

ADD ALL INGREDIENTS TO A MIXING GLASS, ADD LARGE ICE, STIR THOROUGHLY, TASTE FOR BALANCE, SLOWLY POUR INTO GLASS, GARNISH AND SERVE.

Louise Brooks was from the era of dancing flappers, gangsters, and bootlegged liquor. One industrious Captain Bill McCoy started shipping rum up the East Coast,

and legally sold good booze to the rum-runners. There were many followers, but the word quickly spread that the good stuff was only sold by The Real McCoy.

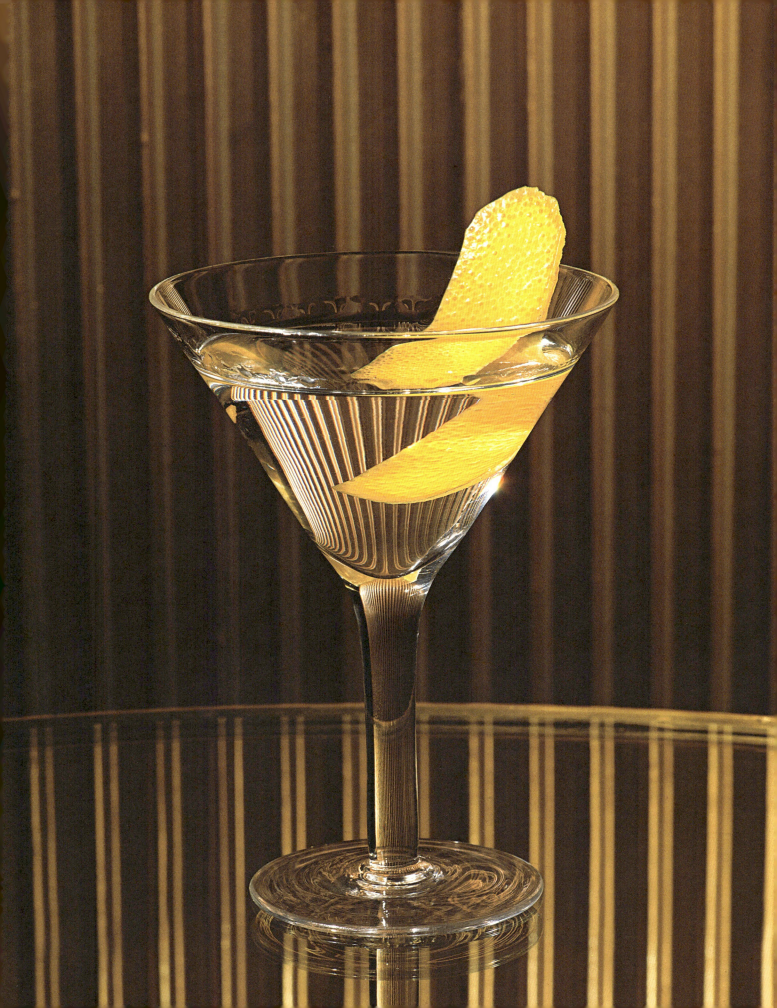

TWISTED TEQUILA

2 oz. SAUZA CONMEMORATIVO ANESO TEQUILA

GARNISH: ORANGE PEEL

PLACE ONE LARGE CUBE OR SPHERE IN A GLASS AND POUR TEQUILA OVER THE TOP, GARNISH AND SERVE.

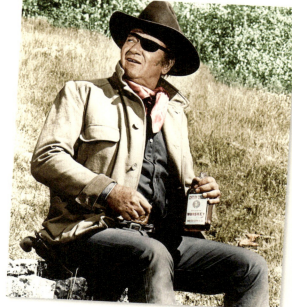

The Duke was a cultural icon who loved a good drink. He reportedly once walked into a stranger's house and, to the delighted bewilderment of the owners, poured himself a stiff belt. John Wayne was regarded as a generous tipper who would often buy the whole bar a round of drinks. He once said, "I drink for comradeship, and when I drink for comradeship, I don't bother to keep count!" The Duke's favorite drink was Sauza Conmemorativo Tequila.

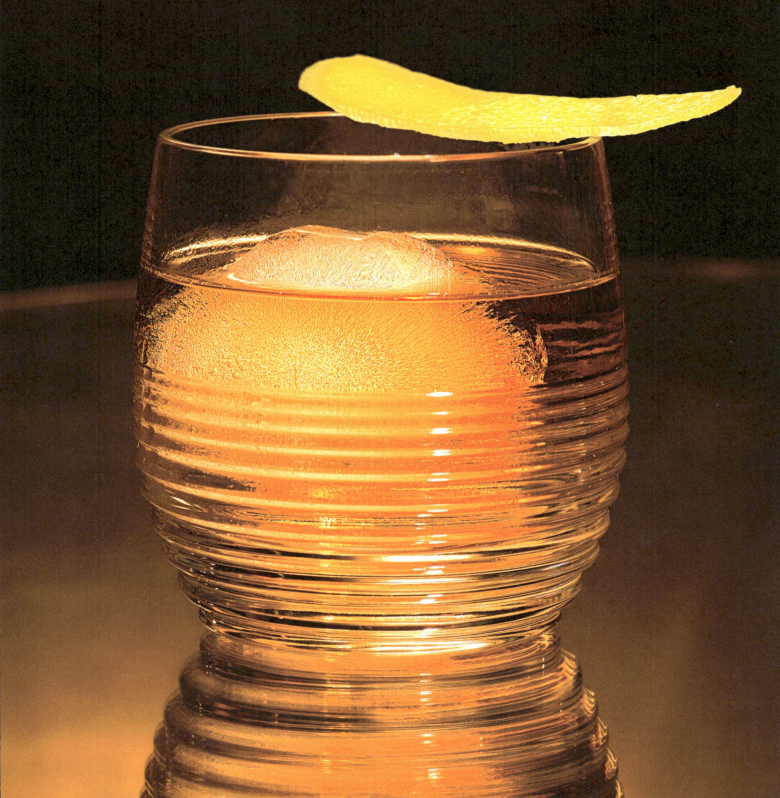

All the best to you—
Clark & Glynis!

"The problem with the world is that everyone is a few drinks behind. "

Humphrey Bogart

Audrey Hepburn in *Paris When it Sizzles*, 1964.

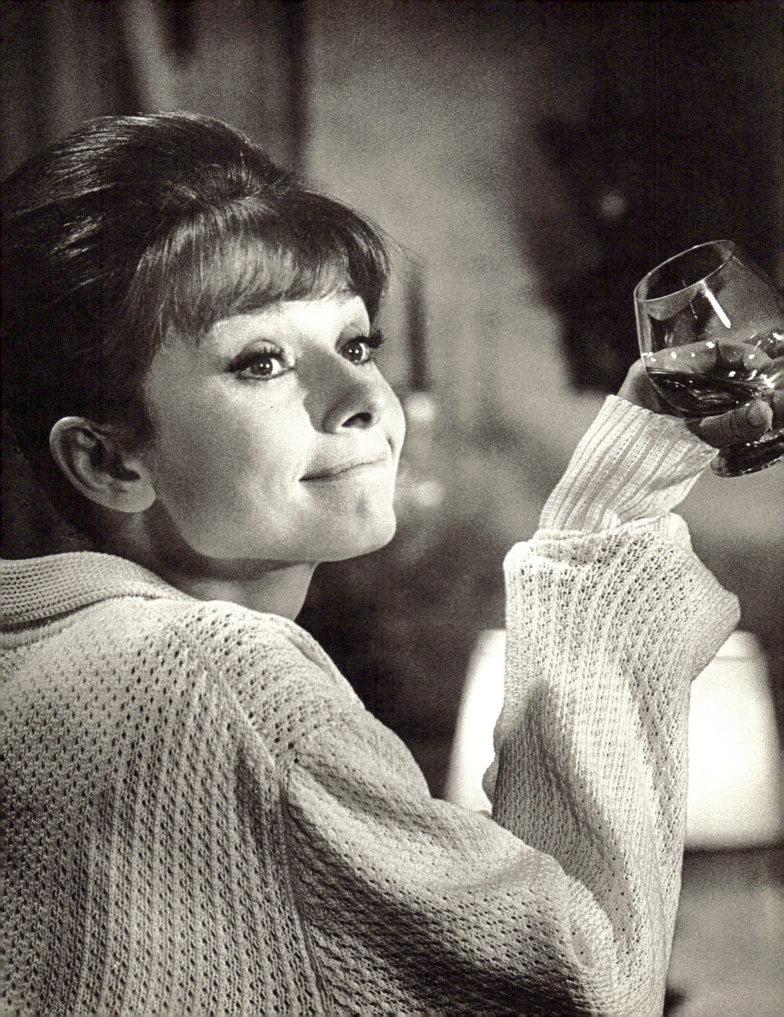

BLOOD AND SAND

3/4 oz. Johnnie Walker Black Label 3/4 oz. Blood Orange Juice 3/4 oz. Punt e Mes Sweet Vermouth 3/4 oz. Cherry Heering GARNISH: Several Flamed Orange Peels

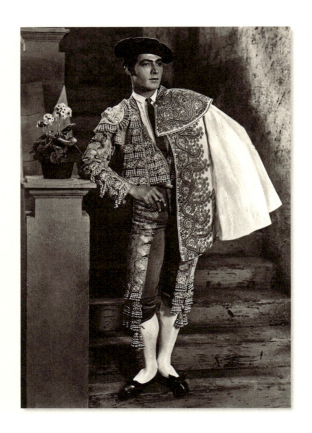

Place all ingredients into a mixing tin, add large ice, shake vigorously, taste for balance, double strain into glass, garnish and serve.

Blood and Sand is a classic cocktail named for Rudolph Valentino's bullfighter movie *Blood and Sand* (1922). The red juice of the blood orange in the drink helped link it with the film. The recipe first appeared in the 1930 *Savoy Cocktail Book*, and is one of the few classic mixed drinks that include Scotch.

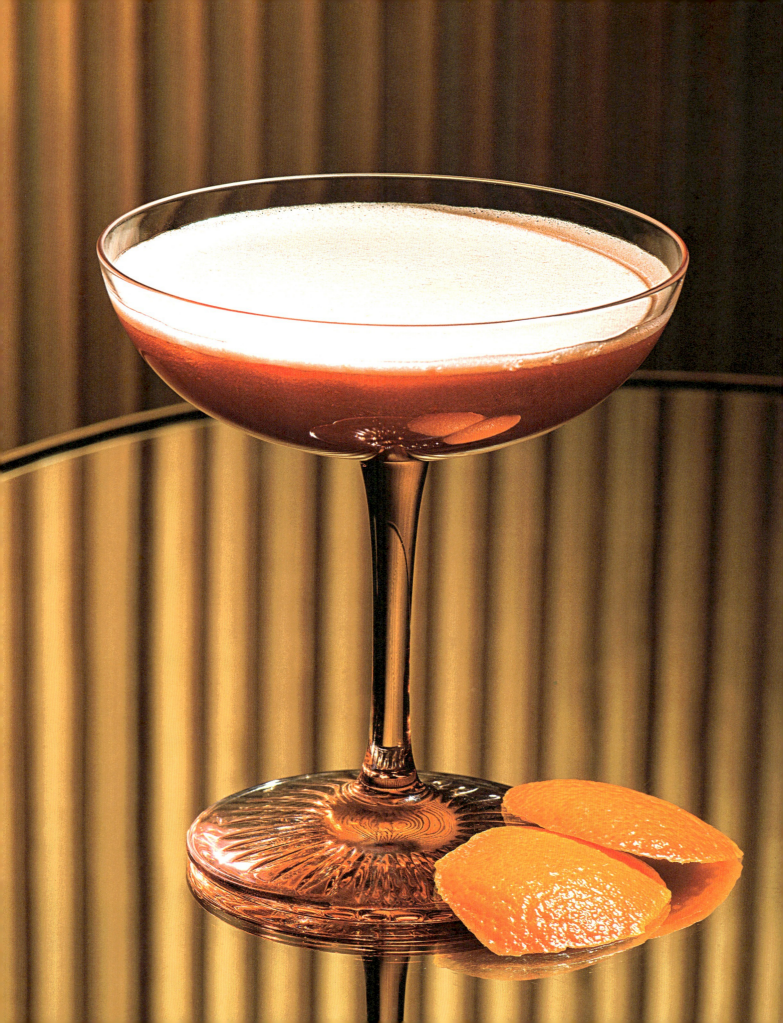

DULCE DE LECHE

2 OZ. BACARDI DARK RUM

1 OZ. CRÈME DE COCOA
(OR DARK GODIVA LIQUEUR)

1 OZ. SWEETENED CONDENSED MILK
(OR 1 OZ. OF HALF AND HALF MILK)

GARNISH: PINCH OF GROUND CINNAMON AND SHAVED CHOCOLATE FOR GARNISH WITH A STRAW.

PLACE ALL INGREDIENTS INTO A MIXING GLASS, ADD LARGE ICE AND SHAKE VIGOROUSLY, TASTE FOR BALANCE, DOUBLE STRAIN INTO HALF COCONUT FILLED WITH LARGE ICE, GARNISH AND SERVE.

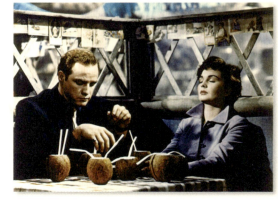

Marlon Brando, Jr.'s character in *Guys and Dolls* (1955), Sky Masterson, takes Sister Sarah Brown, played by Jean Simmons, down to Havana Cuba. As a proper lady and Prohibition teetotaler she requests milk. Masterson orders two Dulce de Leches, which he describes as "sweet milk with a local preservative." When she naively asks what the preservative is, Brando responds in his most innocent tone: "Bacardi."

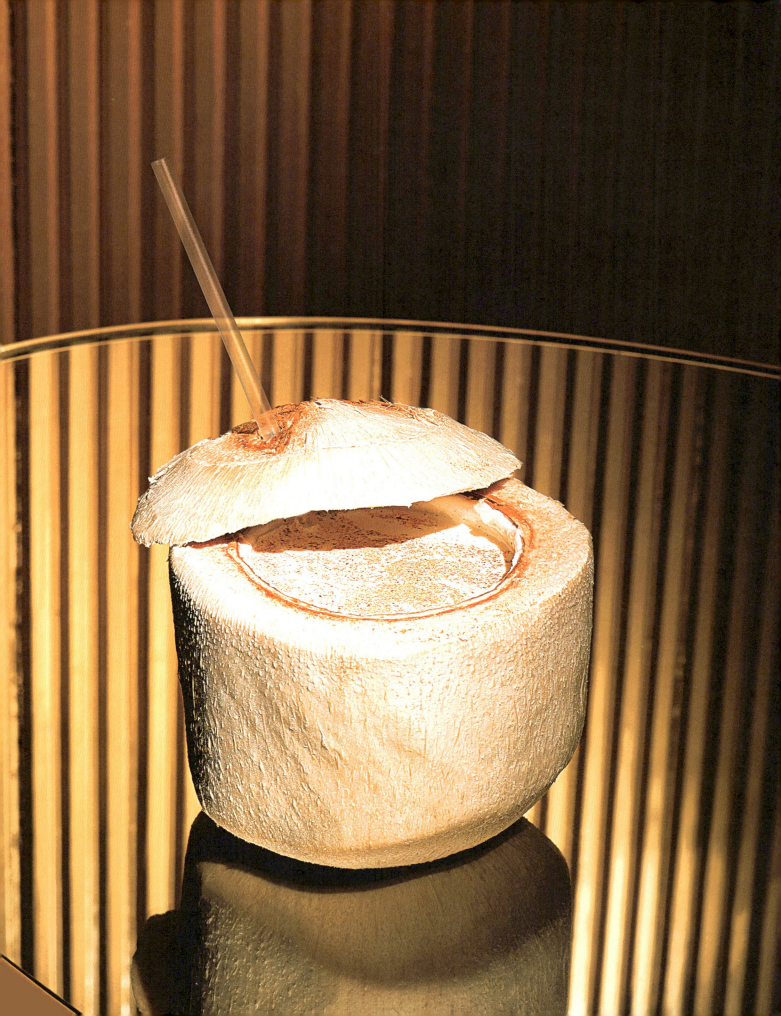

LOS ANGELES COCKTAIL

1 1/2 oz. MAKER'S MARK BOURBON

1/4 oz. DOLIN SWEET VERMOUTH

1 oz. SIMPLE SYRUP

1 WHOLE EGG: EMULSIFIED

1/2 oz. FRESH LEMON JUICE

GARNISH: FRESH GROUND NUTMEG

PLACE ALL INGERDIENTS INTO A MIXING TIN, DRY SHAKE VIGOROUSLY, ADD LARGE ICE AND SHAKE VIGOROUSLY AGAIN, TASTE FOR BALANCE, STRAIN INTO GLASS, GARNISH AND SERVE.

Born in L.A., the Los Angeles Cocktail was first printed in 1930 in the *Savoy Hotel Cocktail Book*, written by famed London barman Harry Craddock. In the midst of Prohibition, the cocktail was being served at the Hi Ho Club in Hollywood frequented by countless celebrities of the day. While the Hi Ho Club is long gone, the Los Angeles Cocktail remains a classic. It is best served in a smaller glass.

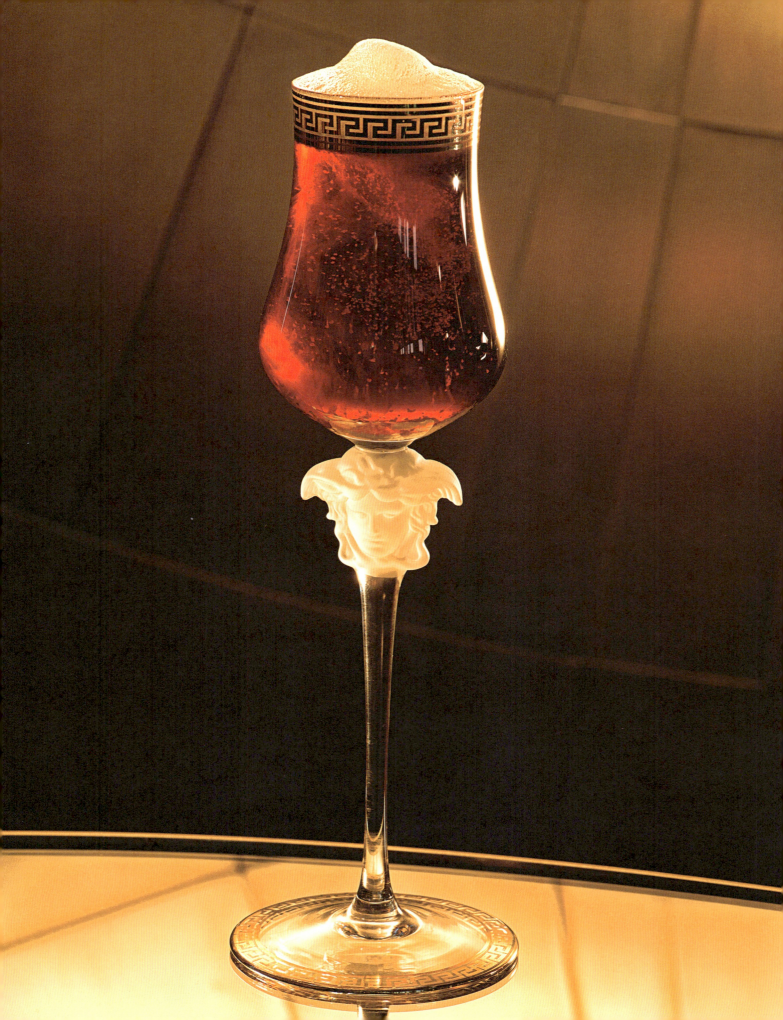

SEX ON THE BEACH

1 1/2 oz. KETEL ONE VODKA
1/2 oz. PEACH SCHNAPPS
1/4 oz. CHAMBORD
2 oz. CRANBERRY JUICE
2 oz. FRESH PINEAPPLE JUICE

PLACE ALL INGREDIENTS INTO A MIXING GLASS, ADD LARGE ICE AND SHAKE THOROUGHLY, DOUBLE STRAIN IN GLASS OVER FRESH ICE, GARNISH AND SERVE.

There is a myth that the Sex on the Beach cocktail was inspired by a scene from *From Here to Eternity* (1953), starring Burt Lancaster and Deborah Kerr.
In fact, the cocktail was likely created in the eighties during spring break in Fort Lauderdale, Florida. The short-lived cocktail was laid to rest in New Orleans in 2010, when the top bartenders in the world held a mock funeral at the world's preeminent cocktail event, Tales of the Cocktail.

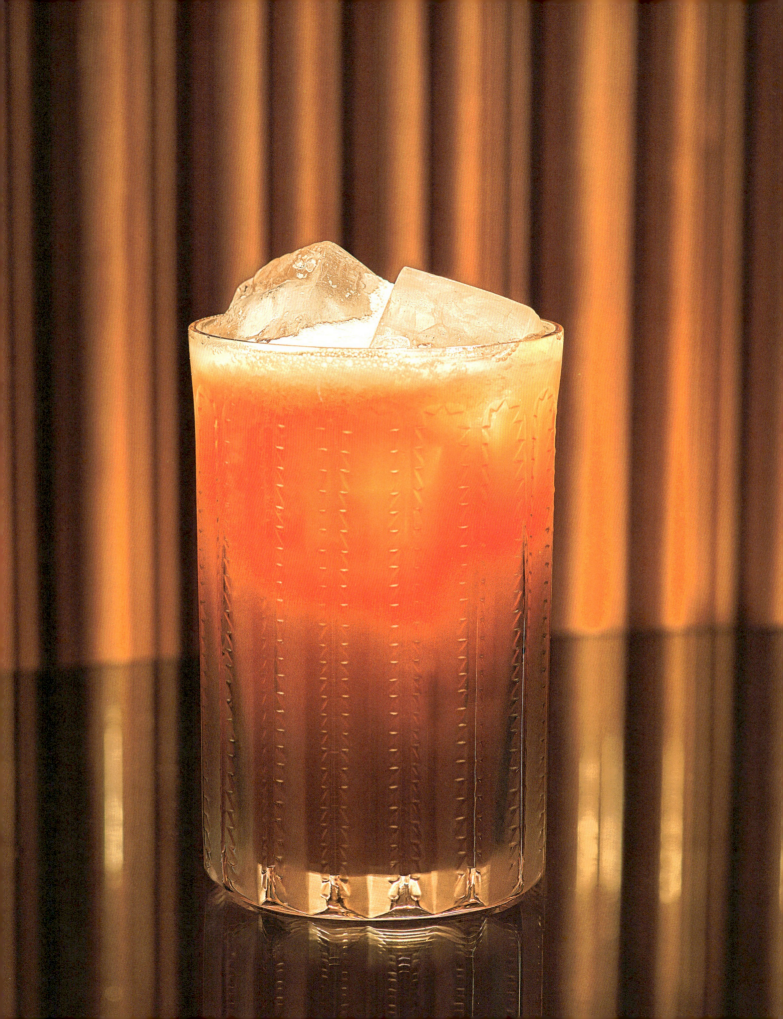

PRINCESS COCKTAIL

2 oz. MAKER'S MARK BOURBON

1 oz. MONIN GRENADINE
(MADE WITH CANE SUGAR)

2 oz. HALF AND HALF MILK

GARNISH : POMEGRANATE SEEDS

PLACE ALL INGREDIENTS INTO A MIXING TIN,
ADD LARGE ICE AND SHAKE VIGOROUSLY.
TASTE FOR BALANCE,
STRAIN OVER FRESH ICE,
GARNISH AND SERVE.

Grace Patricia Kelly was an American film actress
who became the Princess of Monaco when she married
Prince Rainier III in 1956. She retired from
acting at twenty-six to begin her duties in Monaco.
The country of Monaco celebrated in grand style;
even bartenders toasted the event, serving a new drink
called the Princess Cocktail, made with bourbon,
grenadine, and fresh cream.

138

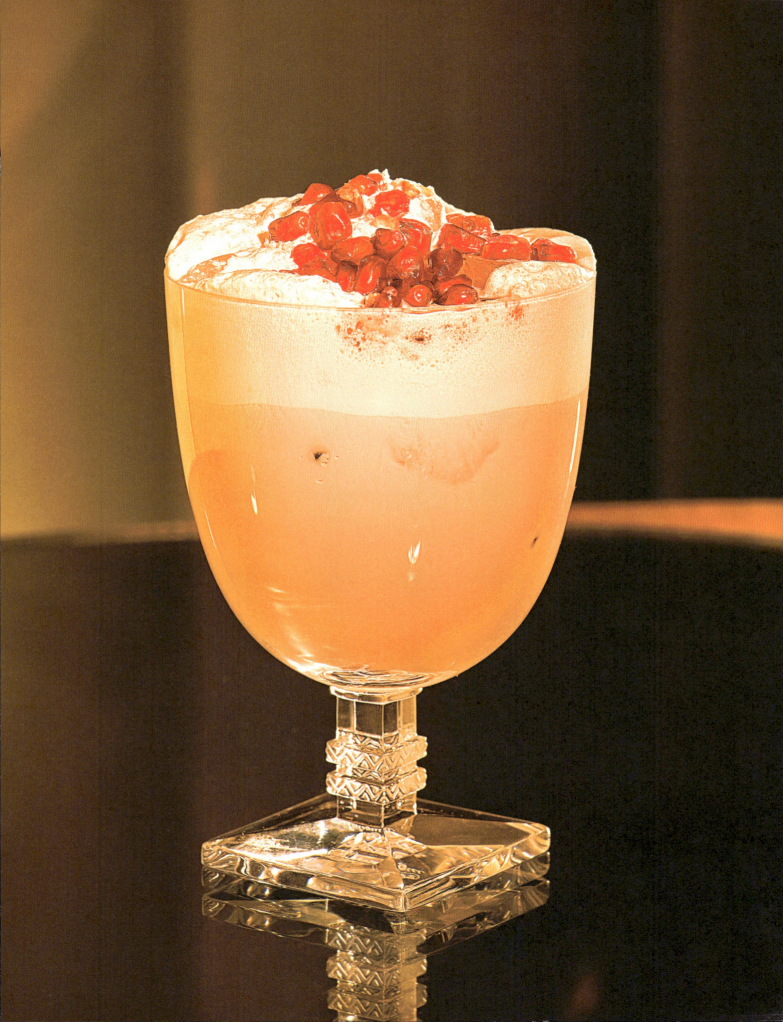

SNAPDRAGON
(OR FLAP-DRAGON)

2 oz. HENNESSY V.S.O.P. COGNAC
100 BRANDY-SOAKED YELLOW RAISINS

GARNISH: WATERFORD SERVING DISH

SOAK RAISINS IN COGNAC AT ROOM TEMPERATURE FOR 24 HOURS. DRAIN RAISINS AND PLACE THEM IN THE CENTER OF A PLATE IN A SMALL PILE. POUR DRAINED COGNAC OVER TOP OF RAISINS AND IGNITE WITH WOODEN MATCH (MAKE SURE TO LET THE CARBON BURN OFF.) EXTINGUISH FLAME AND EAT THE RAISINS WHILE SIPPING THE HEATED BRANDY.

✗ NOTE: IT IS NOT RECOMMENDED THAT YOU SNATCH RAISINS FROM THE PLATE WHILE IT'S STILL IGNITED.

Laurence Olivier is widely considered to have been the greatest Shakespearean actor of the twentieth century. In *A Winter's Tale*, Shakespeare refers to a parlor game called Snapdragon, popular from the sixteenth to the nineteenth centuries. The game, usually played on Christmas Eve, involves pouring Cognac in a wide shallow bowl; then the brandy-soaked raisins are placed in the Cognac and set aflame. The aim of the game was to pluck the flaming raisins out of the brandy and eat them without burning yourself!

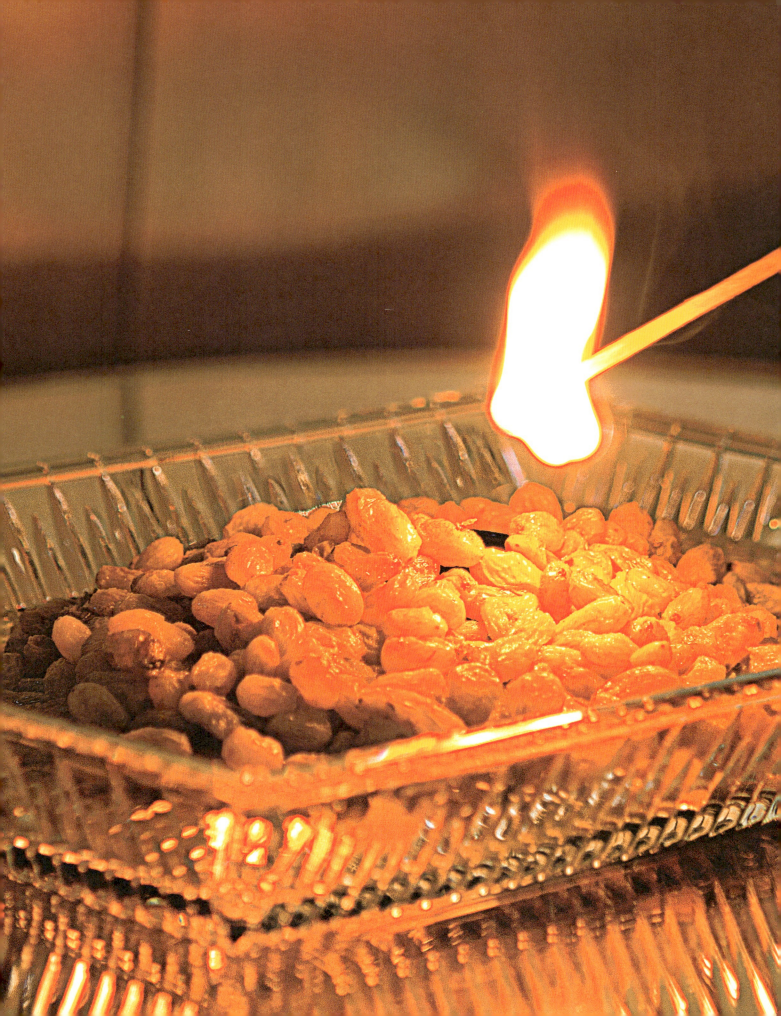

THE GINGER ROGERS

1 1/2 oz. GORDON'S GIN
3/4 oz. GINGER SYRUP
1/2 oz. LIME JUICE
2 1/4 oz. GINGER ALE
3.4 LARGE MINT LEAVES

GARNISH MINT LEAF

PLACE LIME JUICE, GINGER SYRUP, AND MINT LEAVES
INTO TIN, MUDDLE LEAVES THOROUGHLY, ADD GIN AND LARGE
ICE, SHAKE VIGOROUSLY, DOUBLE
STRAIN OVER FRESH ICE,
ADD GINGER ALE, TUMBLE ROLL
BACK AND FORTH ONCE,
GARNISH AND SERVE.

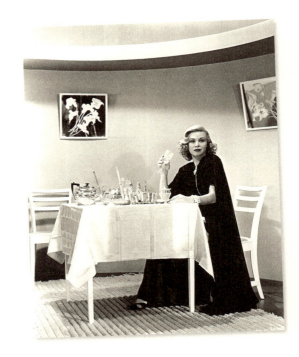

Ginger Rogers collaborated with Fred Astaire
as a romantic lead actress and dancing partner
in a series of ten Hollywood musical films that
revolutionized the genre. In 1995, the year Rogers
passed away, Barman Jeff Hollinger created the
Ginger Rogers cocktail at the Absinthe Brasserie
and Bar in San Francisco, CA. This thoughtful
cocktail has become a modern classic.

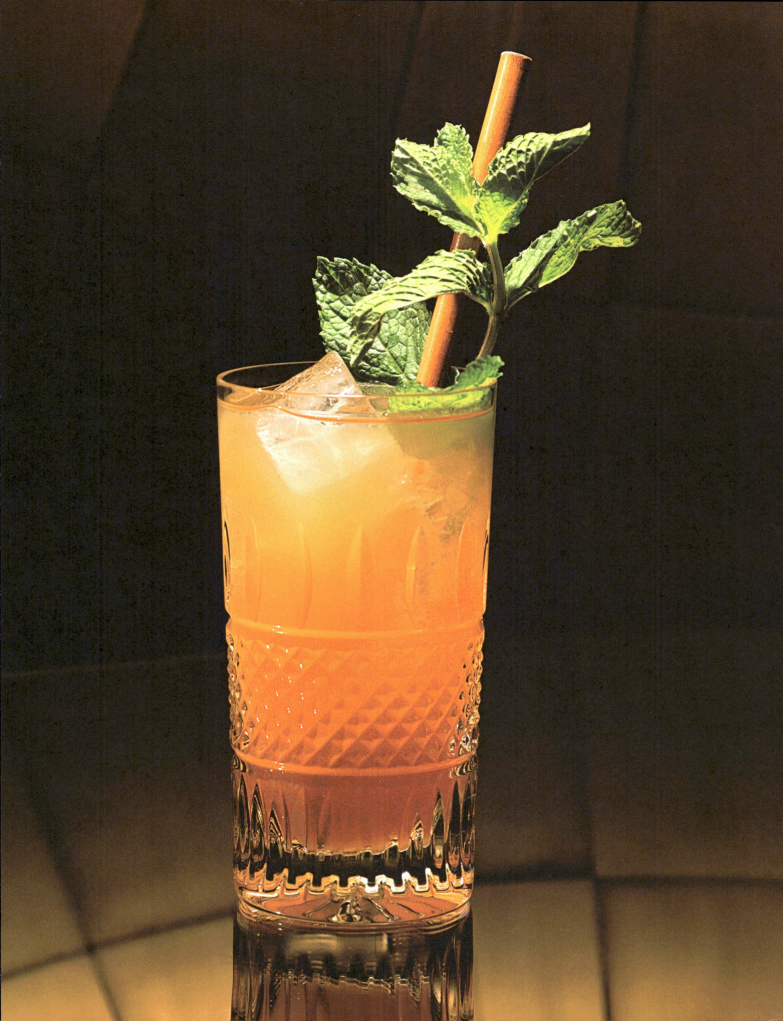

FLAME OF LOVE MARTINI

1/2 OZ. FINO SHERRY 2 1/2 OZ. SMIRNOFF VODKA

GARNISH: SEVERAL FLAMED ORANGE PEELS

COAT THE INSIDE OF A CHILLED MARTINI GLASS WITH FINO SHERRY AND TOSS OUT THE EXCESS, FLAME THE OILS FROM SEVERAL HALF-DOLLAR-SIZED ORANGE PEELS INTO A GLASS FOR A TOUCH OF ACIDITY AND AROMATICS, PLACE ALL INGREDIENTS INTO A MIXING GLASS, ADD LARGE ICE AND STIR THOROUGHLY. GARNISH WITH ORANGE PEELS.

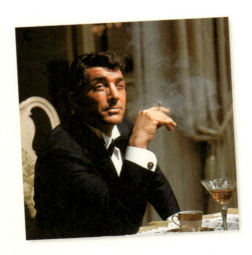

Dean Martin was nicknamed the "King of Cool" for his seemingly effortless charisma and self-assuredness. He was a noted member of the Rat Pack, star singer, and screen personality, but grew tired of drinking traditional Martinis and asked famous Barman Pepe Ruiz, of Chasen's in Beverly Hills, to create "something different" for him. The outcome became Martin's favorite drink and subsequently a favorite of adoring fans everywhere.

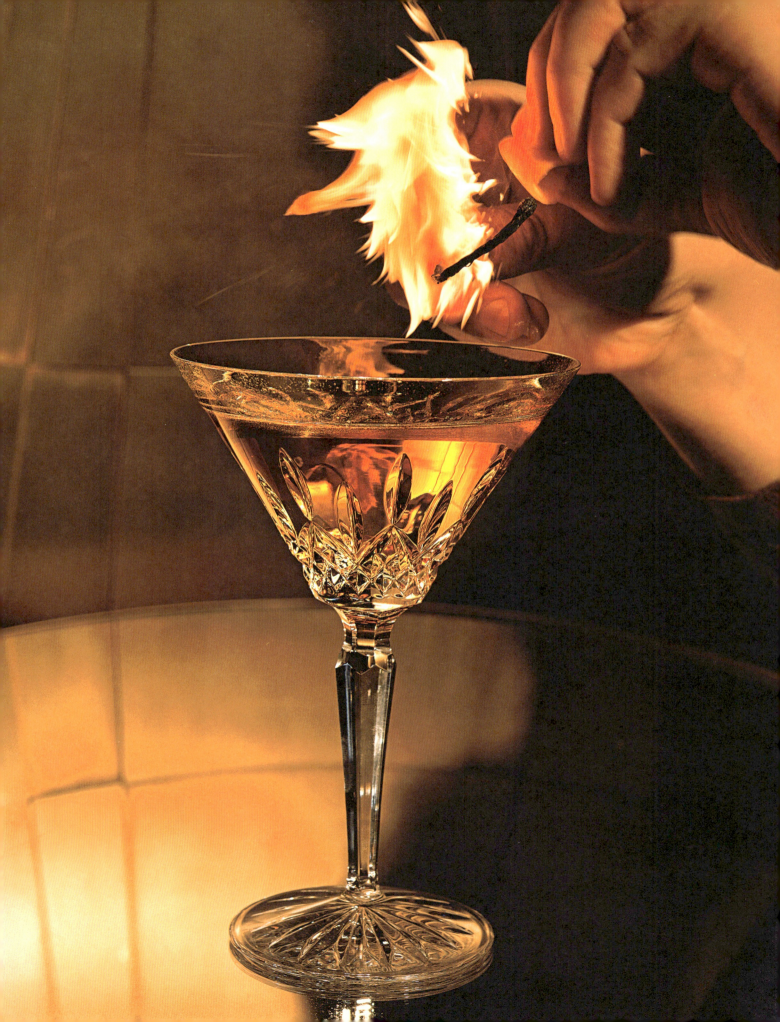

"There was a kindliness about intoxication—there was that indescribable gloss and glamour it gave, like the memories of ephemeral and faded evenings."

F. Scott Fitzgerald
The Beautiful and the Damned

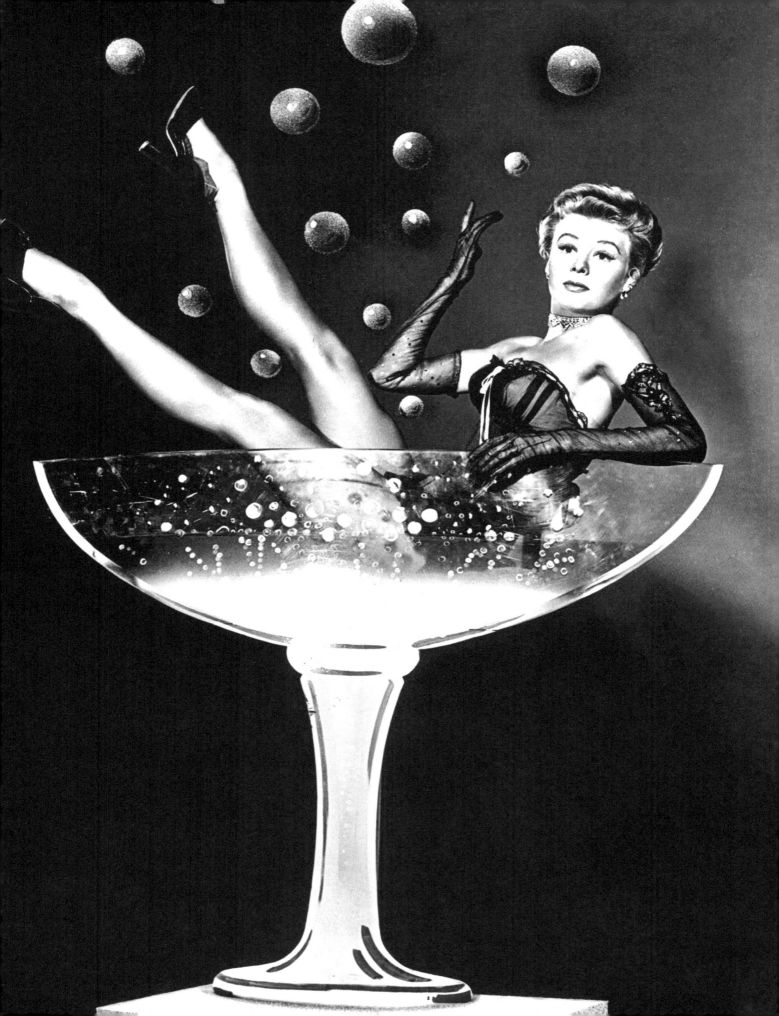

The publisher wishes to thank the photographer, Harald Gottschalk, and all those who helped with the book.

The author would like to thank the following individuals, establishments, and companies for their contribution to this book: Bacardi; Baccarat; Beam Global; Suntory; Dale and Jill DeGroff; Remy-Cointreau; Diageo; Camille Dubois; Tony Abou-Ganim; John and Maria Hardison; James Beard Foundation; Culinary Institute of America; Joey Jalleo, Eileen Cho, and the staff at The Top of the Standard Hotel and Staff; James Menite; Esther Kremer; Harald Gottschalk; Owen Hope; Prosper and Martine Assouline; Kevin and Jennifer Van Flandern; Michael and Melisa Van Flandern; Connie and Phil Sher; Tom and Barbara Van Flandern;Tales of the Cocktail; The United States Bartenders Guild; Per Se Restaurant; Thomas Keller; Andre and Phoebe Mack; Southern Wine and Spirits; The Real McCoy Rum; Arjan Scheepers; The World Ship; The Plaza Hotel; Kelly Gribb; Bridget and Jim Gribb; The New York Distilling Company; Lalique; Fendi (Luxury Living); Waterford Crystal; Rosenthal Glassware; Versace Crystal; Alex and Cory Tabb; Dave McNulty; Jim Meehan; Michael Minnillo; Gary Regan; Whole Foods; Williams Grant. And a special thank you to all the celebrities who were named or participated in the making of this book.

Principal photography by Harald Gottschalk.

Pages 12-13: Keystone-France/Gamma-Keystone via Getty Images; page 14: Photofest; page 16: Time & Life Pictures/Getty Images; page 18: HBO/Photofest; page 20: Everett Collection; page 22: © John Swope Trust/mptvimages.com; page 24: Bruce Yuanyue Bi/Lonely Planet Images/Getty Images; page 26: © 20th Century Fox Film Corp./courtesy Everett Collection; page 28: Time & Life Pictures/Getty Images; page 31: Neal Peters Collection; page 32: Everett Collection; page 34: MGM/The Kobal Collection; page 40: Jerry Tavin/Everett Collection; page 42: © mptvimages.com; page 44: © James Leynse/Corbis; page 46: © Warner Bros./courtesy Everett Collection; page 49: Neal Peters Collection; page 50: © Columbia Pictures; page 52: Everett Collection; page 54: Warner Bros./The Kobal Collection; page 56: Everett Collection; page 58: Warner Bros./The Kobal Collection/Jack Woods; page 60: © Steven Milne/Alamy; page 62: © Warner Bros./courtesy Everett Collection; page 64: Everett Collection; pages 66-67: Paramount Pictures/courtesy Neal Peters Collection; page 70: Everett Collection; page 72: Everett Collection; page 74: Everett Collection; page 76: © mptvimages.com; page 78: Neal Peters Collection; page 80: Everett Collection; page 82: Moviepix/Getty Images; page 84: Columbia Pictures/Photofest; page 86: Everett Collection; page 89: Everett Collection; page 90: © Peter Horree/Alamy; page 92: Everett Collection; page 94: MGM/The Kobal Collection; page 96: ©Warner Bros./courtesy Everett Collection; page 98: Everett Collection; page 100: Eric Estrade/AFP/Getty Images; page 102: Neal Peters Collection; page 104 Warner Bros./The Kobal Collection; page 109: © Everett Collection; page 110: RKO/The Kobal Collection/Alex Kahle; page 112: © Douglas Kirkland/Corbis; page 118: AF Archive/Alamy; page 122: Photofest; page 124: © Süd-Film; page 126: Everett Collection; page 129: Everett Collection; page 130: Paramount Pictures/MPTV; page 132: © Photos 12/Alamy; page 136: Neal Peters Collection; page 138: Gamma-Rapho via Getty Images; page 140: © Universal Pictures/Wilfrid Newton; page 142: © Warner Bros. Pictures; page 144: Everett Collection; page 147: Neal Peters Collection.